KENTUCKY
A PHOTOGRAPHIC CELEBRATION

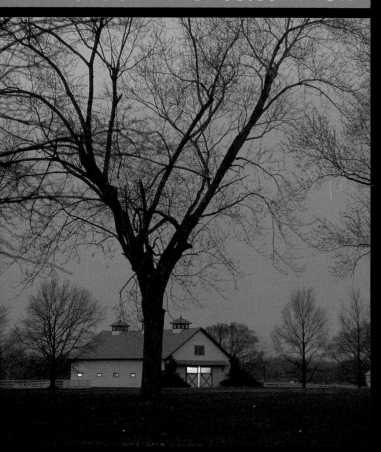

TEXT BY DON EDWARDS
PHOTOGRAPHY BY WILLIAM STRODE

AMERICAN GEOGRAPHIC PUBLISHING

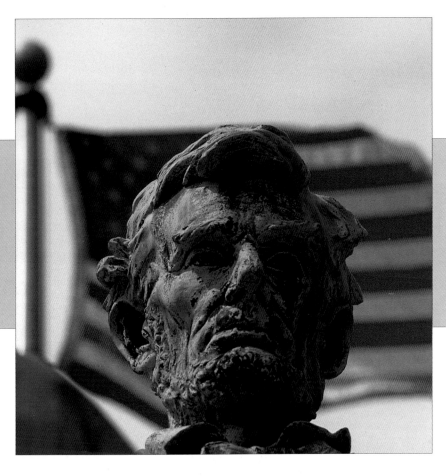

Above: The state's greatest native son.
Right: Cumberland Gap, where the pioneers came through to Kentucky.

ISBN 0-938314-85-8

text © 1990 Don Edwards
photography © 1990 William Strode
© 1990 American Geographic Publishing
P.O. Box 5630, Helena, MT 59604
(406) 443-2842

William A. Cordingley, Chairman
Rick Graetz, President & CEO
Mark O. Thompson, Director of Publications
Barbara Fifer, Production Manager

Printed in Hong Kong

American Geographic Publishing is a corporation for publishing illustrated
geographic information and guides. It is not associated with American
Geographical Society. It has no commercial or legal relationship to and
should not be confused with any other company, society or group using
the words geographic or geographical in its name or its publications.

Title page: Foaling barn, Calumet
Farm.

Front cover: Kentucky thoroughbreds.

Back cover, top: Louisville.
Bottom: Eastern Kentucky mountains
near Middlesboro.

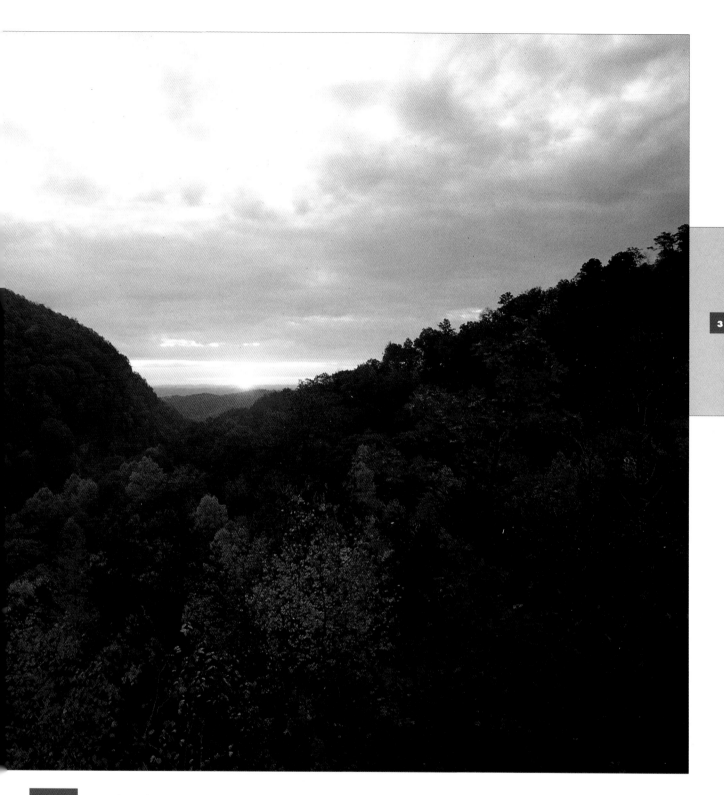

Don Edwards' ancestors arrived in Kentucky about 1780 and gave Daniel Boone a helping hand at Fort Boonesborough.

Edwards, who has won numerous Kentucky Press Association awards, has been writing about his native state as a journalist since 1965, including the past dozen years as a columnist at the *Lexington Herald-Leader*.

William Strode's ancestors also arrived in Kentucky with Daniel Boone, and Captain John Strode established Strodes Station (now the city of Winchester), the state's third permanent settlement. Photographer Strode, who lives near his native Louisville, travels the world on photographic assignments for such publications as *Time, Life, Geo* and *Smithsonian*.

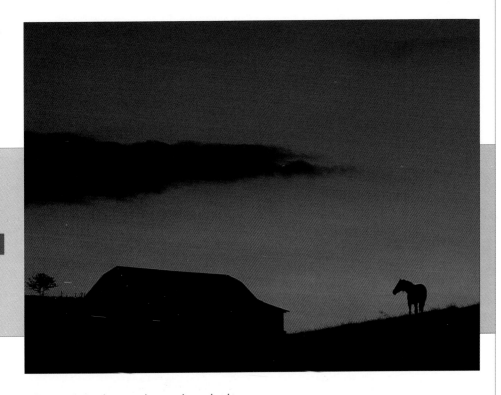

Above: *For a horse, day ends at the barn.*
Below: *Autumn on a Kentucky farm.*

Facing page: *Spring brings new life.*

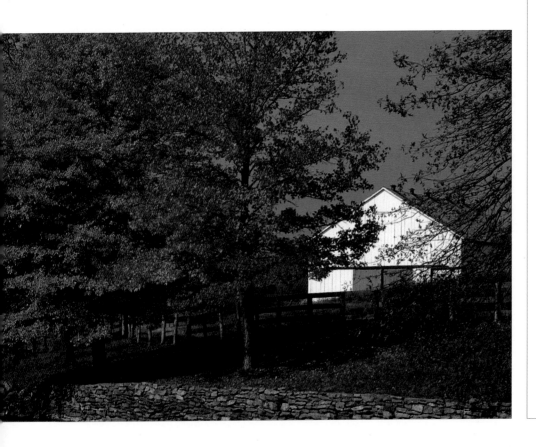

In Kentucky

by James H. Mulligan

The moonlight falls the softest
 In Kentucky;
The summer days come oftest
 In Kentucky;
Friendship is the strongest,
Love's light glows the longest,
Yet, wrong is always wrongest
 In Kentucky.

Life's burdens bear the lightest
 In Kentucky;
The home fires burn the brightest
 In Kentucky;
While players are the keenest,
Cards come out the meanest,
The pocket empties cleanest
 In Kentucky.

The sun shines ever brightest
 In Kentucky;
The breezes whisper lightest
 In Kentucky;
Plain girls are the fewest,
Their little hearts the truest,
Maidens' eyes the bluest
 In Kentucky;

Orators are the grandest
 In Kentucky;
Officials are the blandest
 In Kentucky;
Boys are all the fliest,
Danger ever nighest,
Taxes are the highest
 In Kentucky;

The bluegrass waves the bluest
 In Kentucky;
Yet, bluebloods are the fewest
 In Kentucky;
Moonshine is the clearest,
By no means the dearest,
And, yet, it acts the queerest
 In Kentucky;

The dovenotes are the saddest
 In Kentucky;
The streams dance on the gladdest
 In Kentucky;
Pistol hands the slickest,
The cylinder turns quickest
 In Kentucky;

The song birds are the sweetest
 In Kentucky;
The thoroughbreds are fleetest
 In Kentucky;
Mountains tower proudest,
Thunder peals the loudest,
The landscape is the grandest
And politics—the damnedest
 In Kentucky.

ames H. Mulligan's humorous little poem, "In Kentucky," first published in a Lexington newspaper in 1902, captures perfectly the mixture of heartfelt sentimentality and good-natured cynicism that Kentuckians feel about their state. In its time, Mulligan's poem was enormously popular. Had he copyrighted it, it would have earned him a fortune; its verses appeared on more than a million souvenir postcards sold in Kentucky. Today it is nearly forgotten. Its message, however, remains valid. Kentucky, it tells us, is a place of contradictions.

Nothing more true could ever be said about the 15th state admitted to the Union. It is a contradictory kind of place.

Its famous pioneer, Daniel Boone, staked claim to 100,000 acres of land, then lost every square foot of it in the courts. Disgusted, he moved west to Missouri. Its greatest political native son, Abraham Lincoln, never won an election in Kentucky.

Its cherished state song, "My Old Kentucky Home," was written by a man from Pittsburgh who never owned or rented a home in Kentucky.

Its classic sporting event, the Kentucky Derby, was an idea borrowed from England and transplanted to Louisville so that the state's largest city would have an annual big event to rival New Orleans' Mardi Gras.

Its heralded whiskey (and any other alcoholic beverage) cannot be legally sold in three fourths of the state. Nowhere but Kentucky do so many bourbon distilleries and Baptist teetotalers stand side by side. And its best-known entrepreneur of the 20th century, Colonel Harland Sanders, originator of Kentucky Fried Chicken, didn't originate in Kentucky. He was born and learned to cook—in Indiana. Kentucky stretches from the Appalachian Mountains to the Mississippi River, and is 40,395 square miles of undeniable charm and irrepressible cussedness.

It is a place that fascinates people, even from afar. Scott wrote of its canebrakes, Tennyson of its Mammoth Cave and Byron of Boone's exploits, but none of the three ever set foot in Kentucky. Its name comes from an Indian word, linguists agree. But there is disagreement on whether it was a Shawnee, Iroquois or Cherokee word and exactly what it meant: "great meadow" or "dark and bloody ground" or "the land where we shall go tomorrow."

Kentucky was settled in 1769, first organized as Kentucky County, Virginia, and finally became a state in 1792.

The state seal of the Commonwealth of Kentucky depicts a frontiersman in buckskins and a gentleman in long frock coat shaking hands. The handshake did not last long. Like Boone, most of the people who fought the Indians did not end up owning the land.

In Virginia, political favoritism in the form of Kentucky land grants was so common in the 18th century that Virginians had a saying when they didn't see a neighbor for several weeks. They said:

"He's gone either to hell or Kentucky."

Many of the land grants went to well connected second sons of Virginia plantation owners whose first sons would inherit in Virginia. Those second sons brought to Kentucky a plantation mentality and traditions of racing horses and distilling untaxed whiskey. It was all quite natural. In those days, you didn't get to Kentucky without a good horse to carry you over the mountains. And after such an arduous journey, you were ready for a refreshing drink when you arrived.

The drink was bourbon, "moonshine with a pedigree," some Kentuckian once christened it. It was carefully distilled, lovingly aged-in-wood corn whiskey named for Bourbon County, Kentucky.

The county was not named for the whiskey. Kentucky had been formed in the frontier crucible of the Revolutionary War, and took many of its place names according to patriotism.

Bourbon County was named for the Royal House of Bourbon in France, which gave aid and comfort to America during the war. The state's two largest cities and their counties, Louisville in Jeffer-

son County and Lexington in Fayette County, took their names from King Louis XVI, Thomas Jefferson, the Battle of Lexington and the Marquis de Lafayette.

The villages of Kentucky showed considerably more originality in choosing place names. Visitors to the state are invariably amused by such names as Hell-'fer-Sartain and Monkey's Eyebrow. Once Kentucky became a state, it showed a veritable passion for dividing itself. It was still forming new counties as late as 1912, and ended with an astonishing number—120 counties. Only Texas and Georgia have more.

Ask a Kentuckian where he's from, and he's as likely to give you the name of his home county as his hometown. This provincialism of 120 little political kingdoms, however, has created serious problems for the state in such endeavors as education reform.

But Kentuckians love their counties nearly as much as they love basketball. They will fight with guns, knives, fists and money over whom they elect to local and state offices, then pay scant attention to whom they send to Washington.

A favorite anecdote is about a Kentuckian who returns home for a visit after years of living out of state and asks what became of a former classmate.

"He tried farming and went bankrupt," the visitor is told.

"Then he tried law and went bankrupt. Then he tried business and went bankrupt."

"I'm sorry to hear he's such a failure," says the visitor.

"He's no failure," says the informant. "He's our Congressman."

How do outsiders see Kentucky? In their *Book of America: Inside Fifty States Today* (Norton, 1983), authors Neal R. Pierce and Jerry Hagstrom summed up Kentucky in three words: "diverse, genteel and violent."

There is some salient truth to all three characterizations. Kentucky is so geographically diverse that its beloved writer Jesse Stuart once observed, "Actually, we [Kentuckians] are strangers to one another."

Stuart proposed busing Kentuckians from opposite ends of the state. That way, mountain people from the east could see cotton growing in the

west; western soybean farmers could see the eastern woodlands of the sprawling Daniel Boone National Forest; and horse and tobacco raisers from the central bluegrass region could see coal mines—probably for the first time.

And yes, Kentucky is genteel. Its mint juleps are served in silver cups. Its most beautiful architecture is antebellum. Its Keeneland Race Course, a thoroughbred horse track at Lexington, refuses to install a public address system because it would destroy the ambience of "racing as it was meant to be." It is a Southern-flavored gentility. Technically, at least, Kentucky is the South. Its top border is the Ohio River, part of the Mason-Dixon Line, and its golden age ended with the Civil War.

But Kentucky was terribly divided in that war. Both presidents, Lincoln and Jefferson Davis, were native sons of the state. Kentucky never joined the Confederacy, but it never fully embraced the Union, either.

Warren and the self-proclaimed "greatest" of prizefighters, Muhammad Ali.

Kentuckians are proud and touchy, hard-headed and generous, hospitable and suspicious in nearly equal quantities.

Kentuckians will drop whatever they are doing to go bass fishing, but sit patiently for hours listening to long-winded political oratory. Perhaps that is why the Kentucky Constitution is seven times as long as the U.S. Constitution. Kentuckians like their bread hot and their pie cold, but they love a heated debate almost as much as they love food.

One of the state's listings in the *Guinness Book of World Records* is for 15,000 pounds of barbecued mutton, pork and chicken consumed in one day in 1982 at the annual Fancy Farm Picnic, a stump-speaking contest for political hopefuls.

Kentuckians are fond of family reunions and invariably talk about "the old homeplace" whether they have one or not. "I never met a Kentuckian who wasn't coming home," Colonel Sanders once said.

Some states, such as California, are continually reinventing themselves. Kentucky is a place more likely to recreate itself. Kentuckians like to re-enact Civil War battles and turn out for festivals that celebrate vanishing rural folkways such as sorghum making.

A Kentuckian has a strong sense of gathering people together for any good reason. In Kentucky, swapping knives and 'coon hounds are excellent reasons.

And if, as the old colonel said, every Kentuckian seems to always be headed for home, there is an explanation.

Remember those Virginians who explained a neighbor's absence by saying, "He's gone either to hell or Kentucky"?

The remark caused those who had gone to Kentucky to logically conclude that the place was somewhere opposite of fire and brimstone.

In other words, they figured, Kentucky must be heaven.

Consequently, it was a battleground for both—with two governors (one Union, one Confederate) vying for control and two Kentuckians wearing Union blue for every Kentuckian who wore Confederate gray.

And yes, Kentucky has a long history of violence, from its pioneer days of Indian wars to its much publicized Hatfield-and-McCoy feud a century later; from its hot-tempered aristocrats who fought duels of honor in the 1800s to its murders on the picket lines during coalfield labor disputes of the 1900s. For years, Kentuckians were more likely to settle arguments by reaching for a gun than a law book. One Kentucky governor was assassinated. Even today, Kentuckians elected to state office must take an oath that compels them to swear they "have never fought a duel with deadly weapons."

But there is more to Kentucky than divisive geography, cloying gentility and loaded guns. The Kentucky character is a thing to behold—this is a state that produced both U.S. Poet Laureate Robert Penn

Above: *Danville, where the first Kentucky Constitution was adopted.*

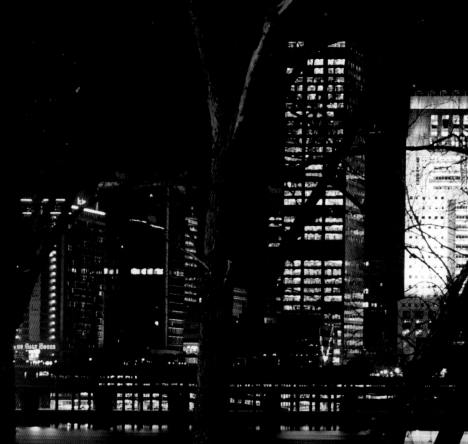

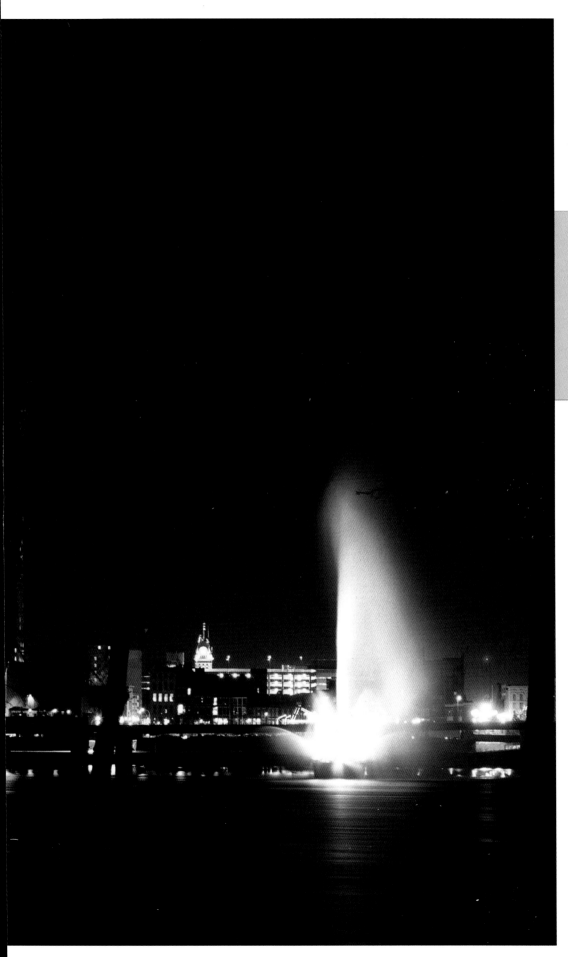

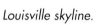

9

Louisville skyline.

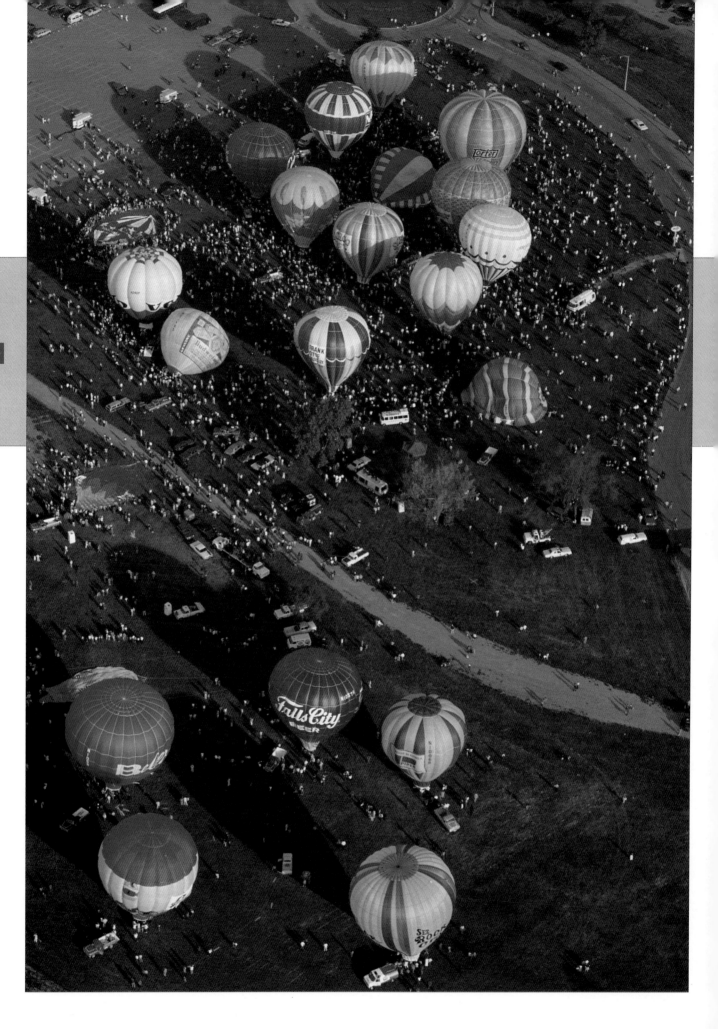

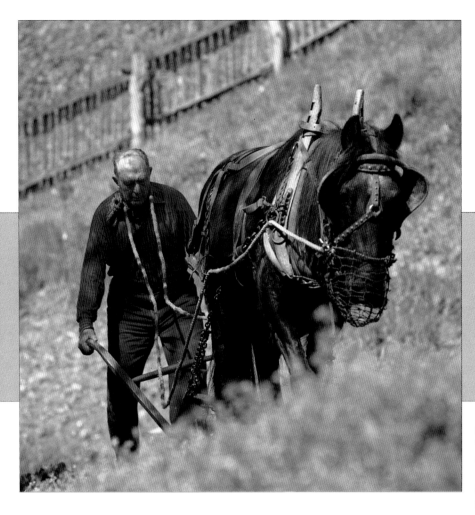

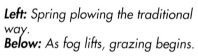

Left: Spring plowing the traditional way.
Below: As fog lifts, grazing begins.

Facing page: Hot air balloon race begins Derby Week festival.

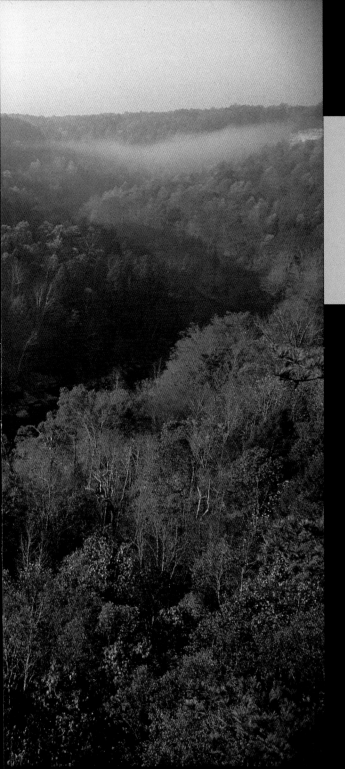

According to the Bureau of the Census, for the first time more Kentuckians live in urban areas than rural ones.

Yet no Kentuckian lives more than a 20-minute drive from a farm or a horse.

The next best thing to being on the land is being near it.

13

Autumn on Rockcastle River in Daniel Boone National Forest.

Right: Actors Theatre of Louisville is a cultural landmark.
Below: Kentucky Lake Dam in the western part of the state.

Facing page: With thousands of miles of shoreline here, an old Kentucky home can be a houseboat.

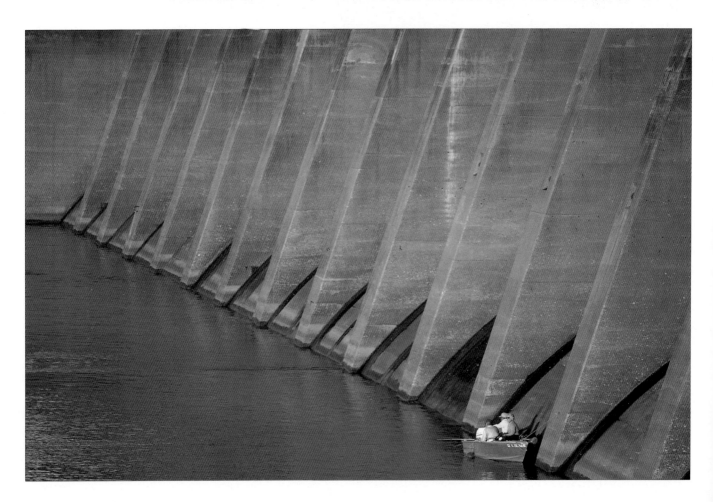

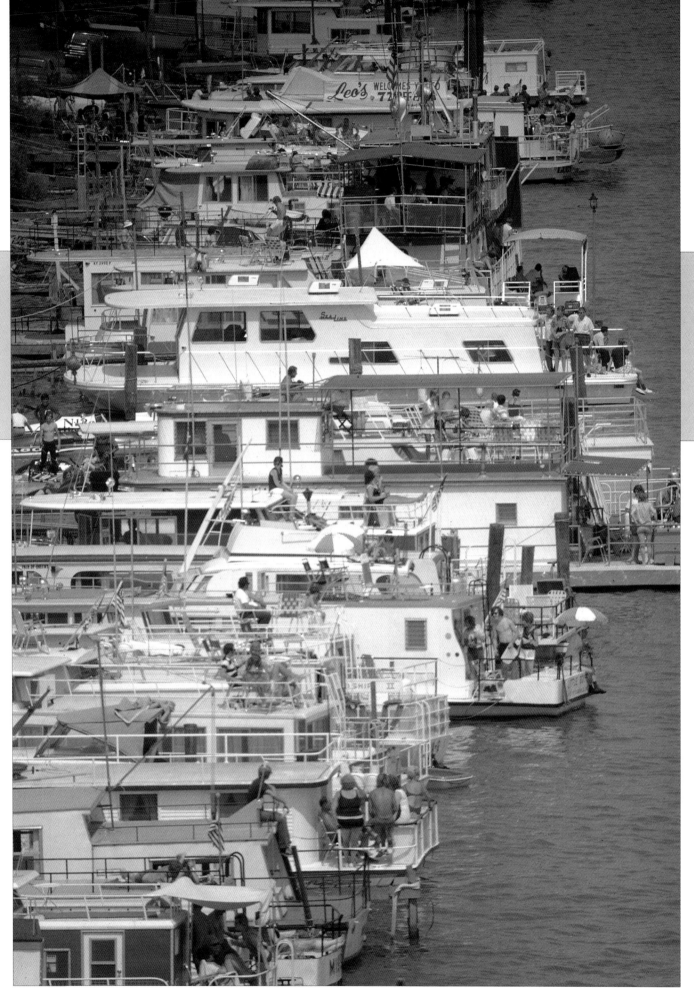

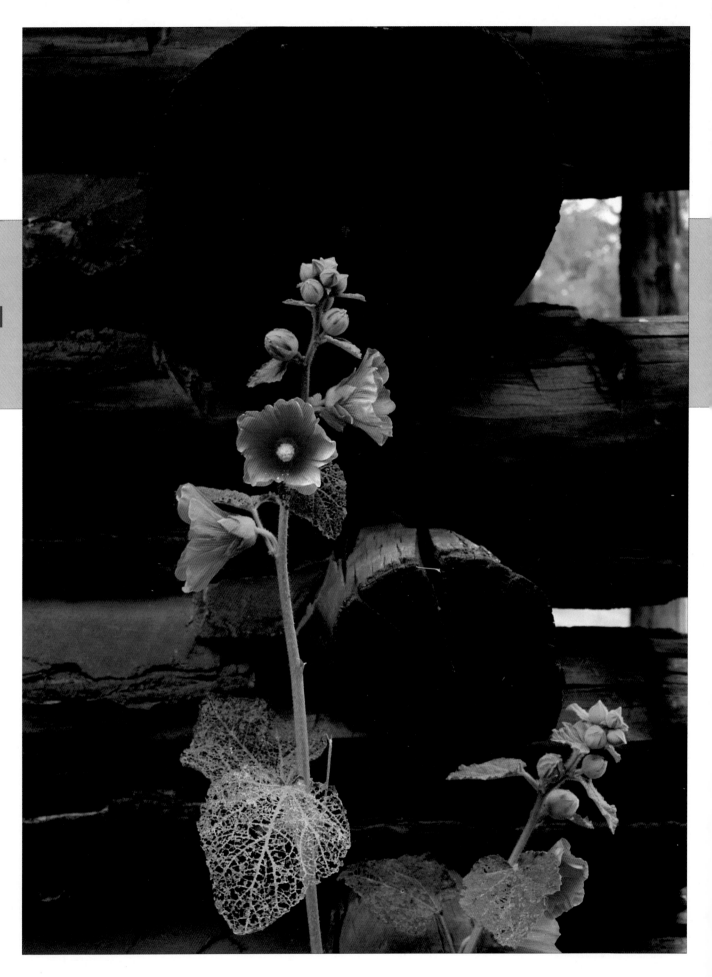

 Kentucky has consolations that can be catalogued, but not measured. They include:

The flash of a cardinal's wings. Goldenrod blooming in sunlight. A gray fox slipping under a white plank fence. Fallow deer circling a pond. A "painted lady" butterfly delicately tattooing the air with color.

For those reasons alone, a person would be no fool to come to this place.

Below: Kentuckians preserve their pioneer churches.

Facing page: Hollyhocks in bloom at Fort Harrod.

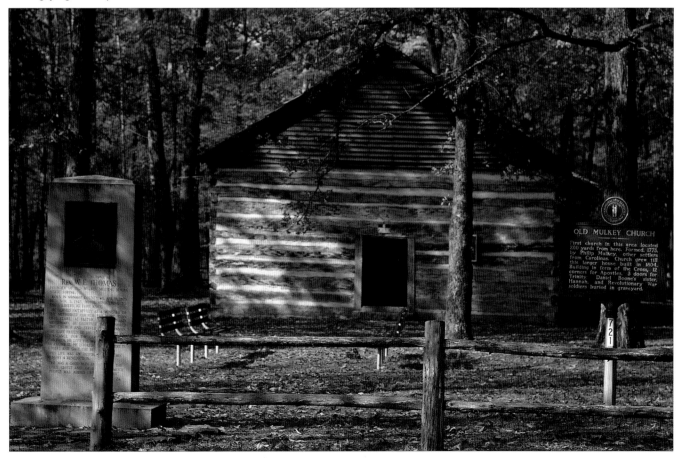

19

Pine Mountain State Park
in the eastern mountains.

Kentuckians love to discern a tourist.

Does he call a ground hog a "woodchuck"? Does he consider corn merely a vegetable and not also a bread?

Most important, does he pronounce the name of the state's largest city "Louie-veal" or correctly say "Luh-vull"?

After making that determination, Kentuckians generally will say, "Welcome, stranger. Where you-all from?"

Below: *Big hats are a Derby Day tradition.*

Facing page: *Splendor in the Bluegrass Region of Central Kentucky, Spendthrift Farm.*

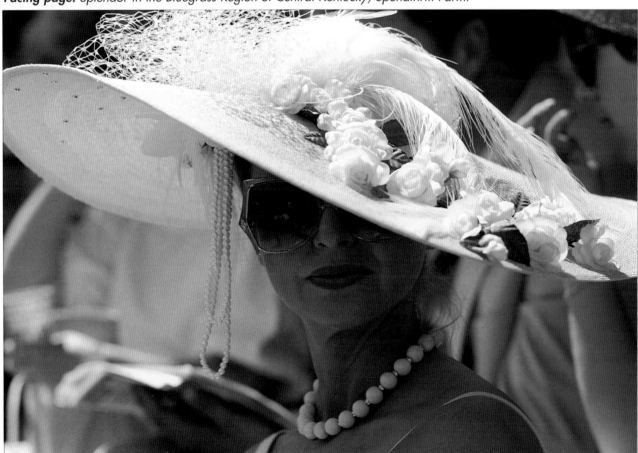

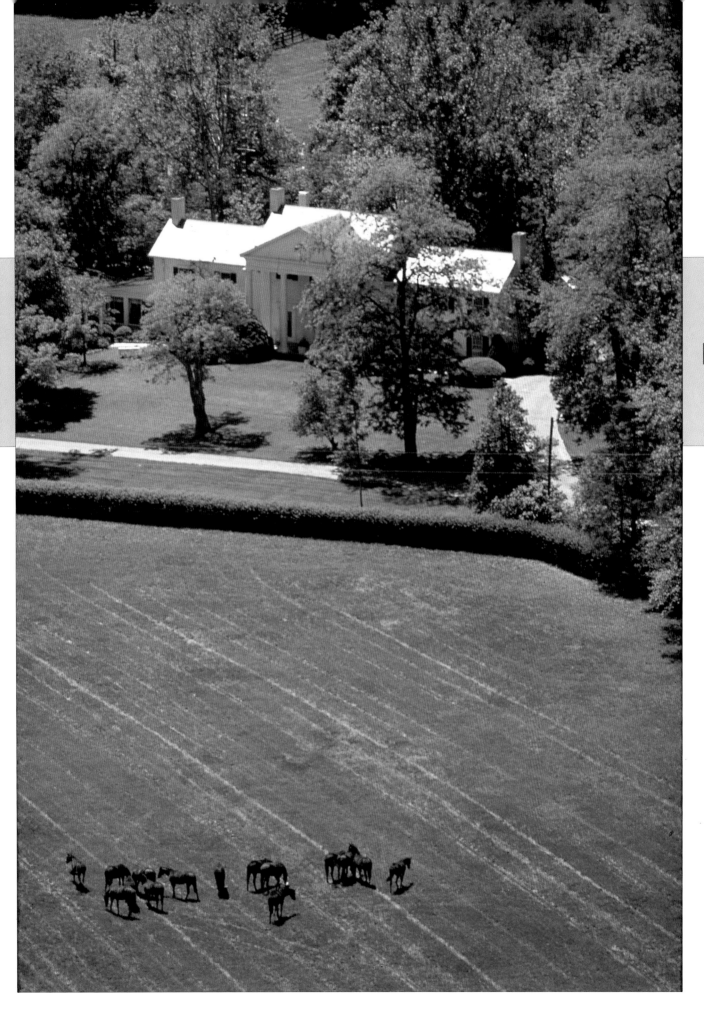

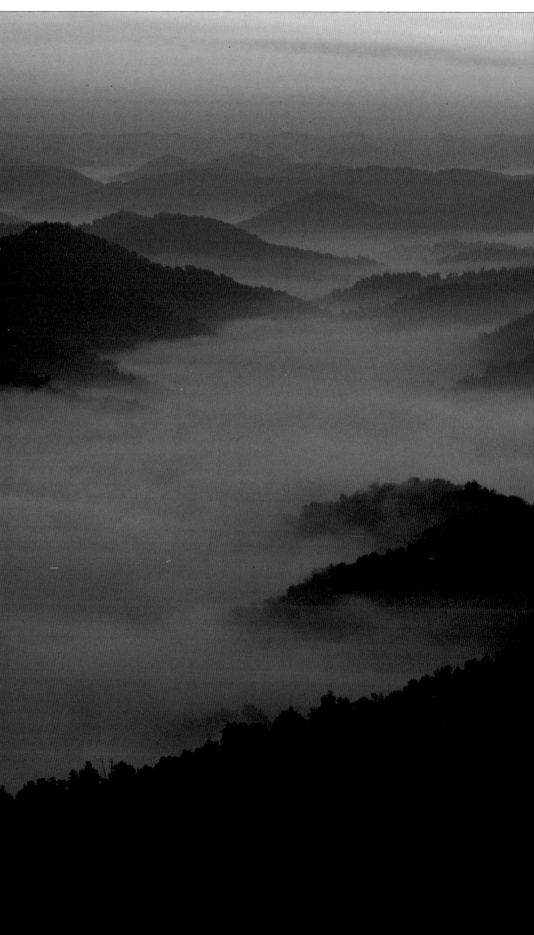

*Morning meets the
mountains.*

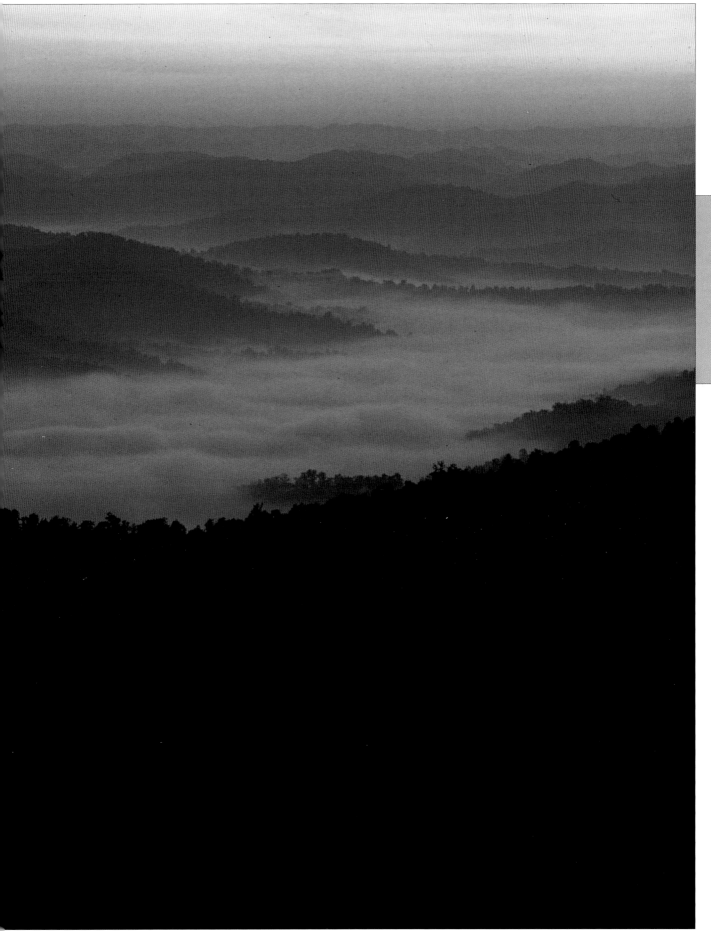

Right: Suppertime—here near Greensboro—is a great Kentucky gathering.

Far right: Despite increasing industrialization, rural Kentucky endures. Near Campbellsville, Green County.

Below: A prize catch about which stories will be told.

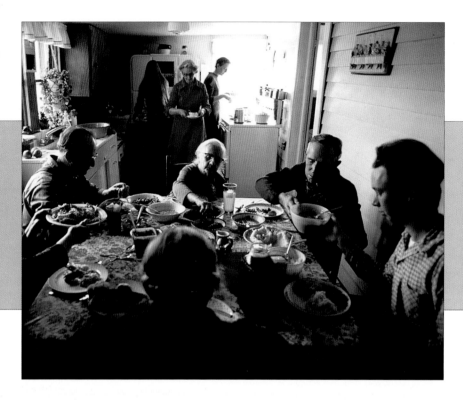

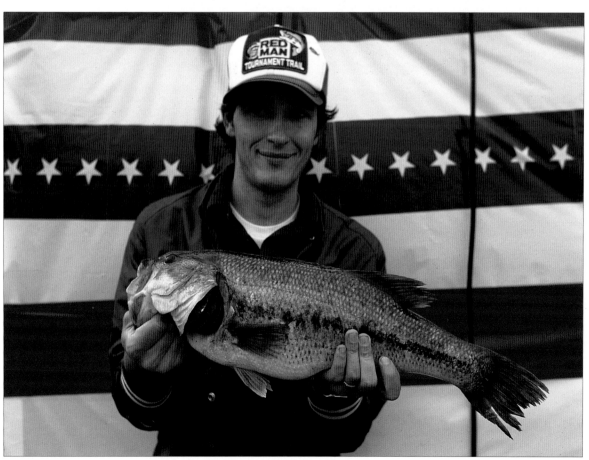

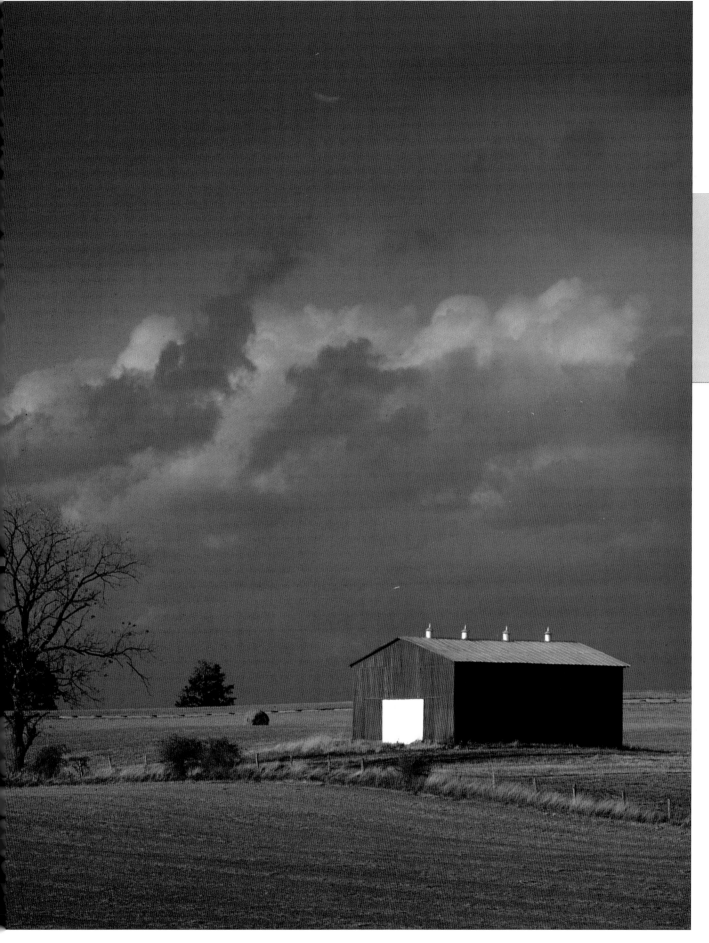

A challenge in the popular Trivial Pursuit game asks players to "name the capital of Kentucky." Most who don't know guess Louisville.

The correct answer is Frankfort, first called Frank's Ford to honor a settler killed by Indians near a shallow spot on the Kentucky River.

Town leaders thought Frank's Ford sounded too rustic. They changed it to Frankfort. Seldom has a place aimed harder at significance, only to hit "Trivial"-ity.

Below: Louisville Riverfront Belvedere near the Falls of the Ohio.

Facing page: Downtown Louisville.

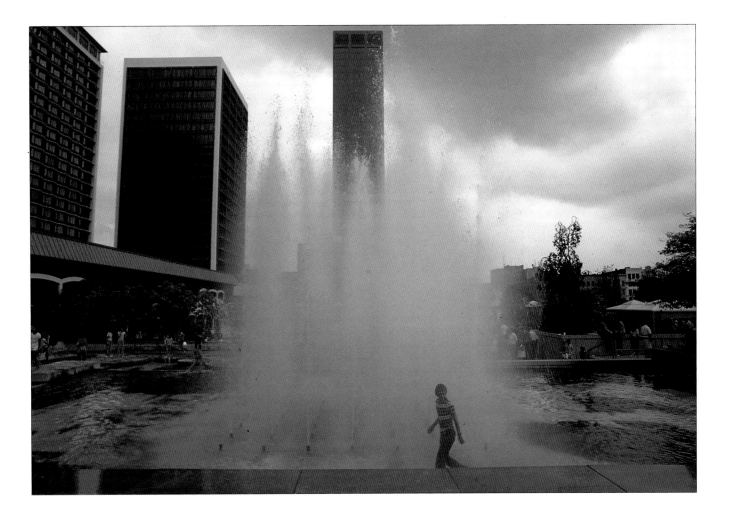

Calumet Farm, the first horse farm many visitors see, is across from Lexington Airport.

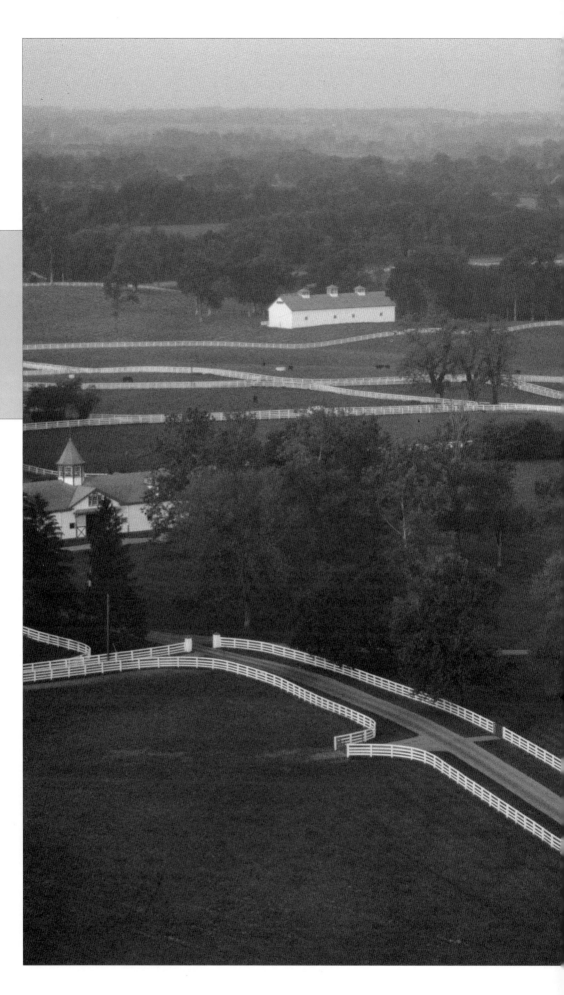

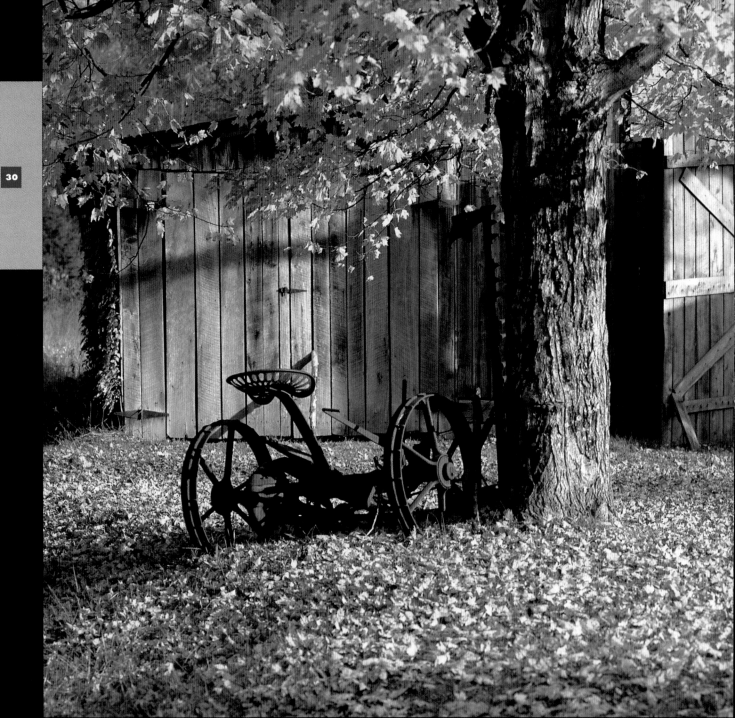

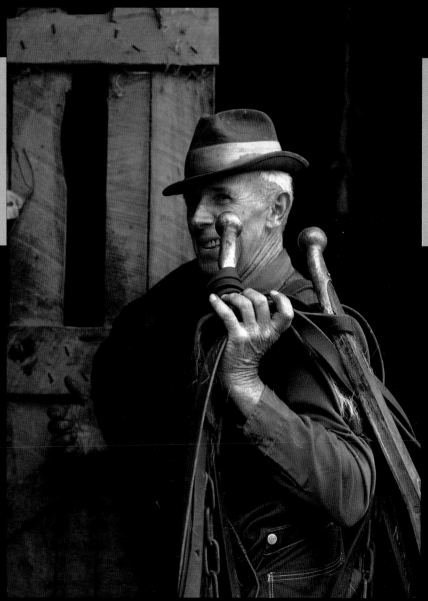

Above: *Ready to harness up.*

Left: *Old-time farm machinery at rest.*

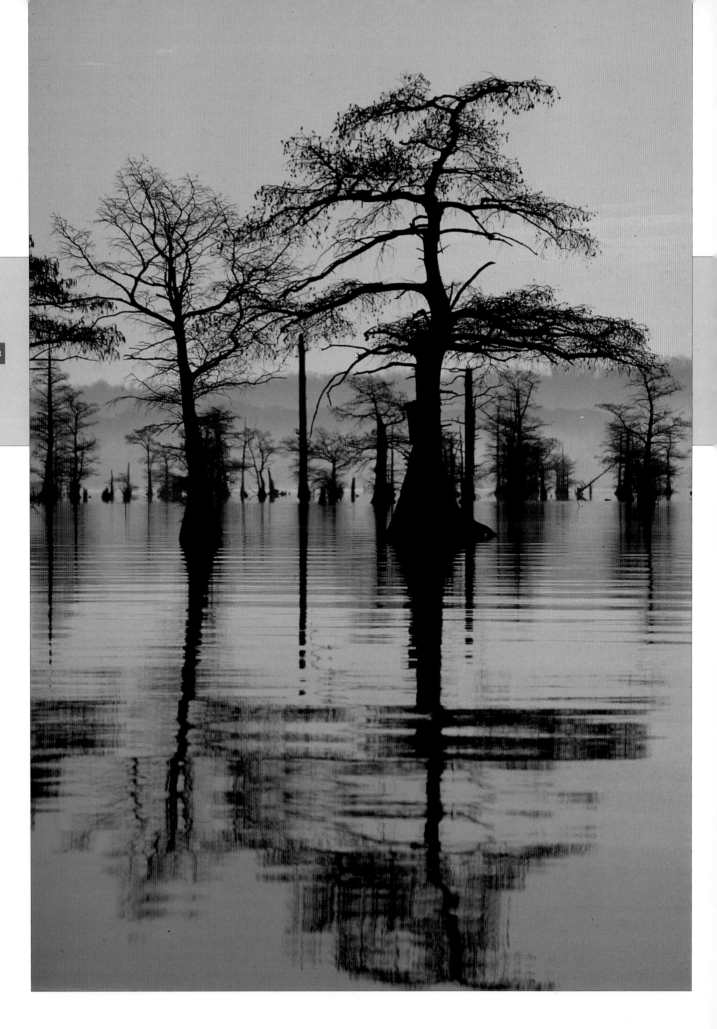

Kentuckians have gone from flatboats and horses to speedboats and automobiles, from sure-footed mules to 4-wheel-drive vehicles. They get there faster, but where are they going?

After the West was settled, the middle part of the country closed up like a zipper.

Below: Autumn forest collage.

Facing page: Reelfoot Lake was created by an earthquake that changed the course of the Mississippi River.

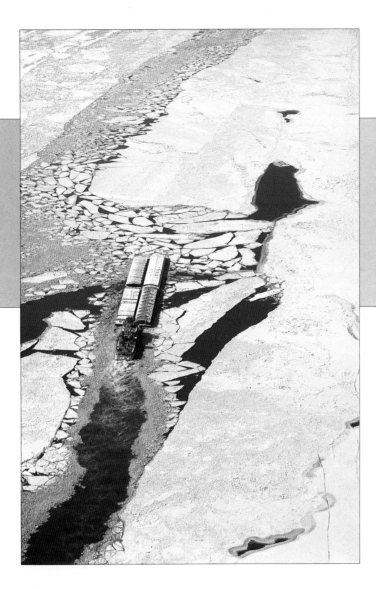

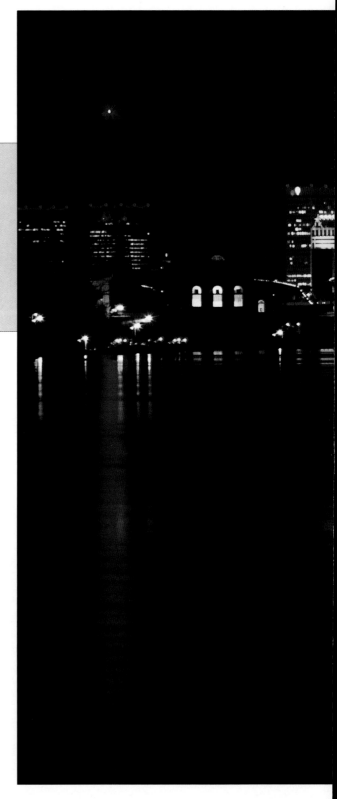

Above: Winter comes, even south of the Mason-Dixon Line,
but the Ohio River very seldom freezes.
Right: City lights of Louisville across the Ohio River.

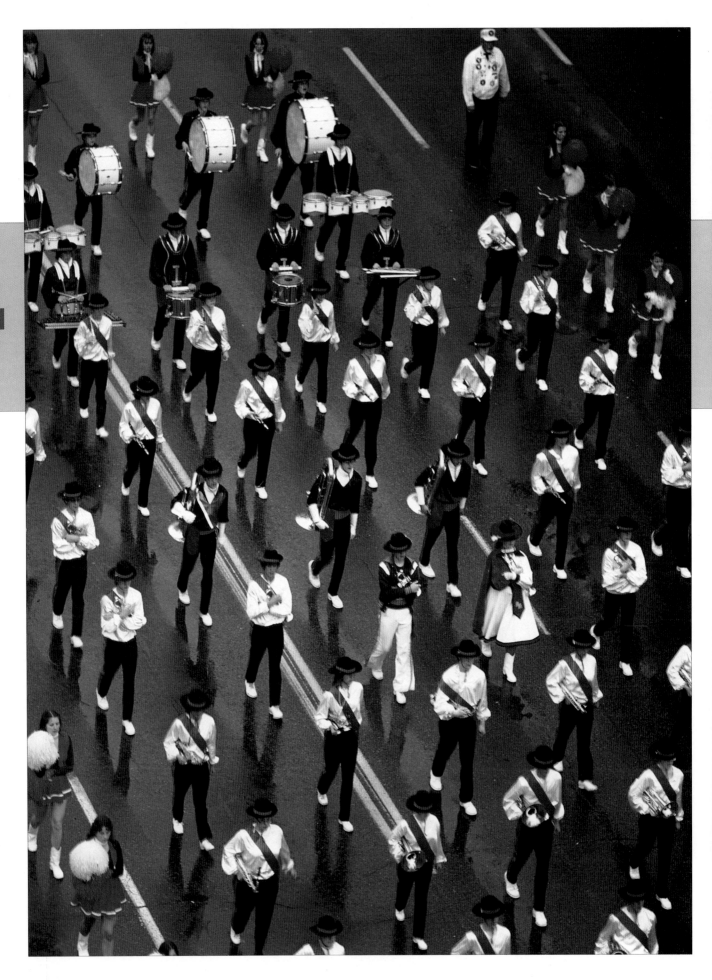

The largest Kentucky Derby party does not take place in Louisville, where the race is run. It is the Derby Eve Party at Hamburg Place in Lexington, a thoroughbred farm that has bred seven Derby winners.

That is as it should be.

To win a Derby, a horse need beat only the dozen or so other thoroughbreds in the race. To breed a Derby winner, a horse farmer must beat 50,000 other thoroughbreds foaled the same year.

Below: Kentucky Derby finish line at Churchill Downs.

Facing page: Derby parade.

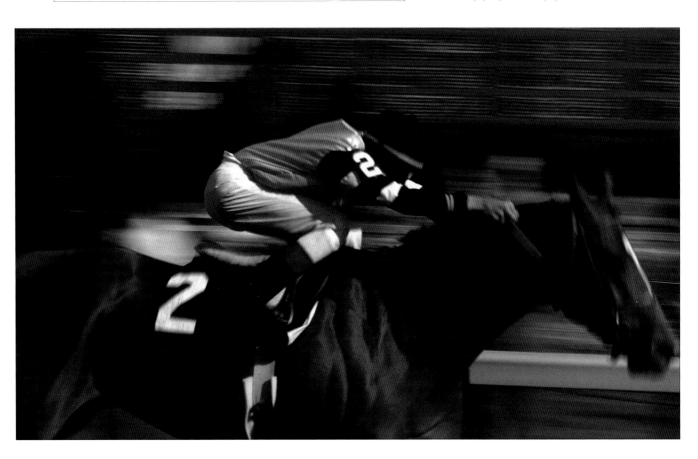

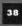
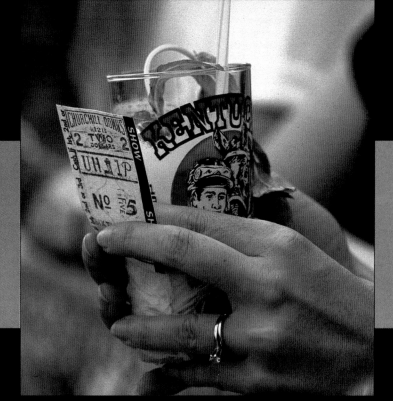
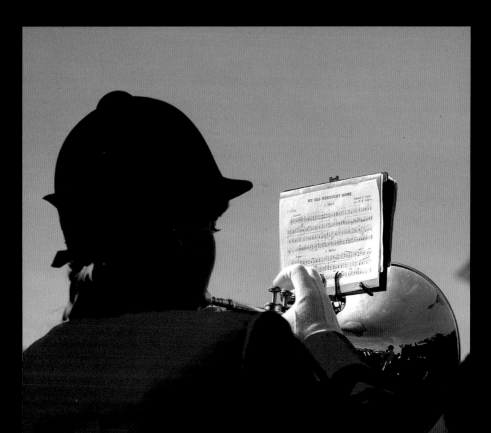
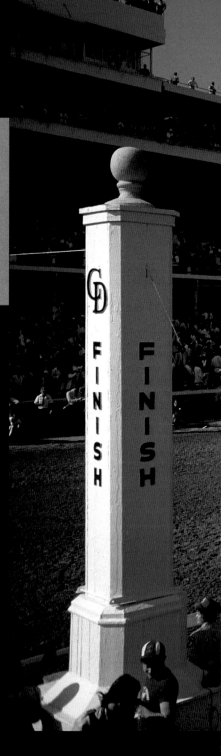

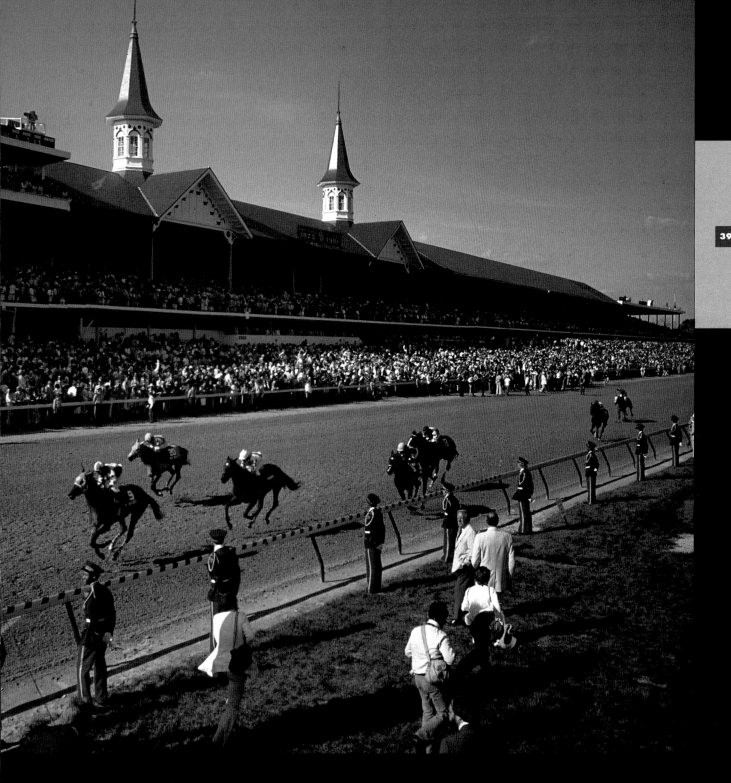

Above: *The world's most famous horse race.*

Facing page, top: *Mint julep and parimutuel ticket.*
Bottom: *The band plays "My Old Kentucky Home."*

In the old days, Kentucky mountain people sang the songs of their British Isles ancestors. Adults played "sure enough" fiddles and children played gourd fiddles and together they sang "Lord Lovell" and "Barbara Allen" and "The Dying Knight's Farewell" and "Lady Isabel and the Elf Knight."

A few still sing these songs, but mainly they are older people. Many of the children are watching MTV.

Most farms are not horse farms. These beef cattle graze near Campbellsville, Green County.

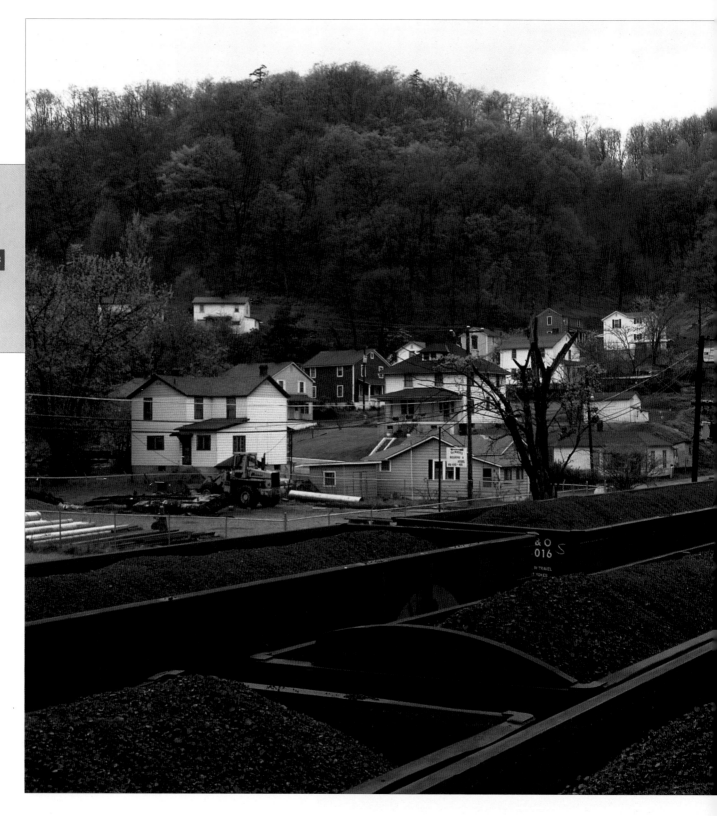

Above: Coal is called the "black gold" of Kentucky, and many eastern Kentucky towns are former coal company towns.

Facing page: A miner's day at the office.

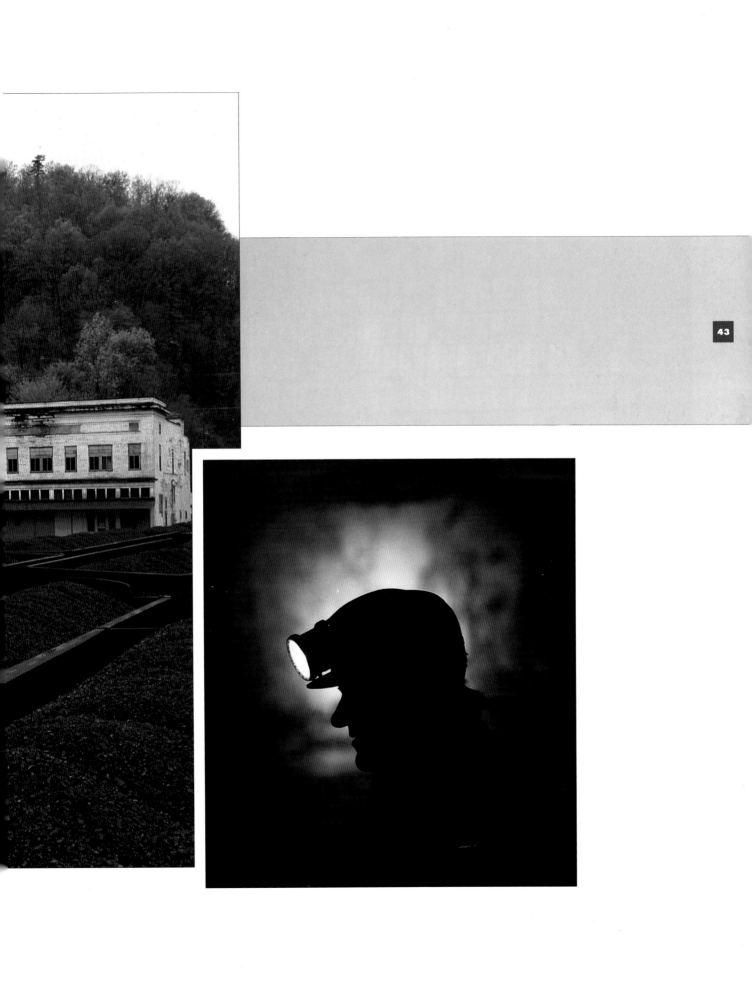

44

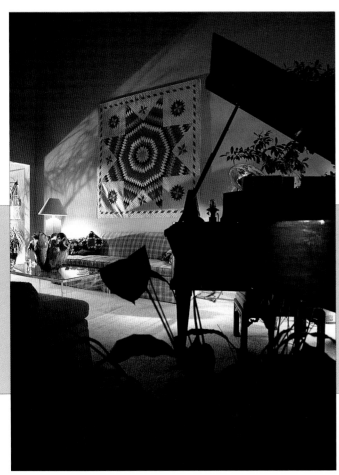

Left: Kentuckians love to display their quilts, as here in a Louisville home.
Below: Roadside scene.

Facing page: Federal gold reserves at Fort Knox.

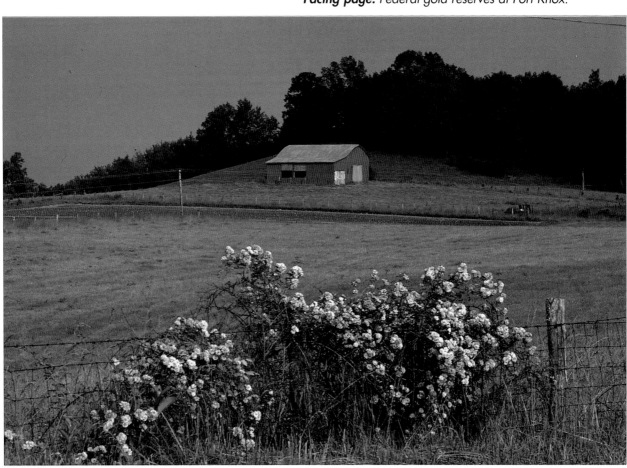

There have been no greater farmers in Kentucky than the Shakers, a religious sect of "brothers and sisters in the Lord."

They milled wood, ground grist, tanned leather and made furniture that looks as if it will last forever. Their land and livestock were fruitful.

The Shakers themselves were celibates.

The last in Kentucky died out in 1925.

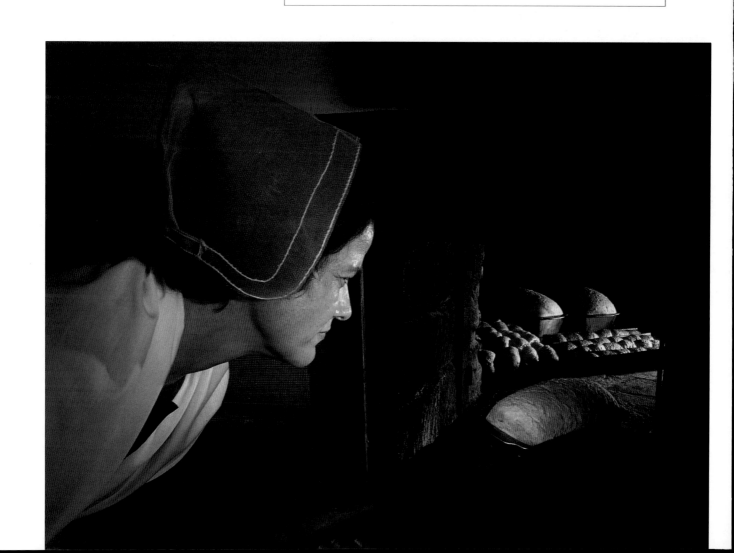

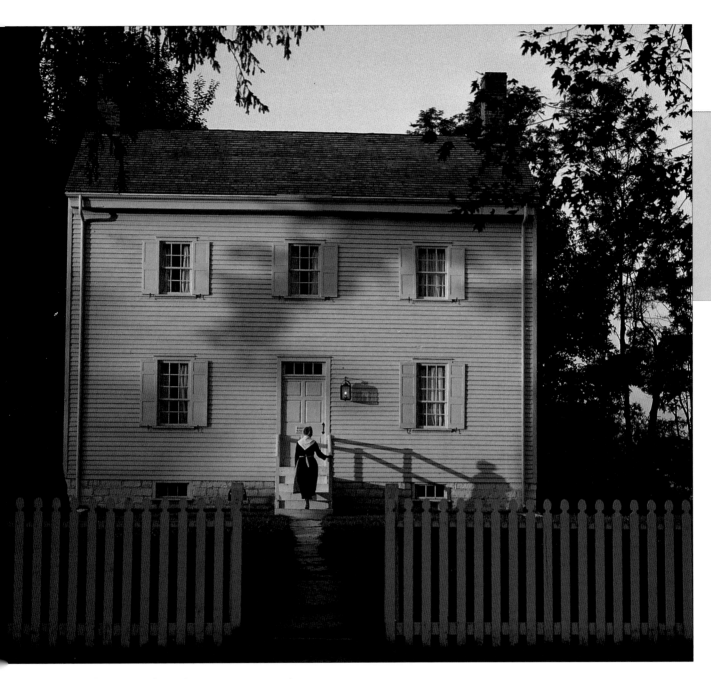

Above: Shakertown, where the past is recreated.

Facing page: Shaker baking.

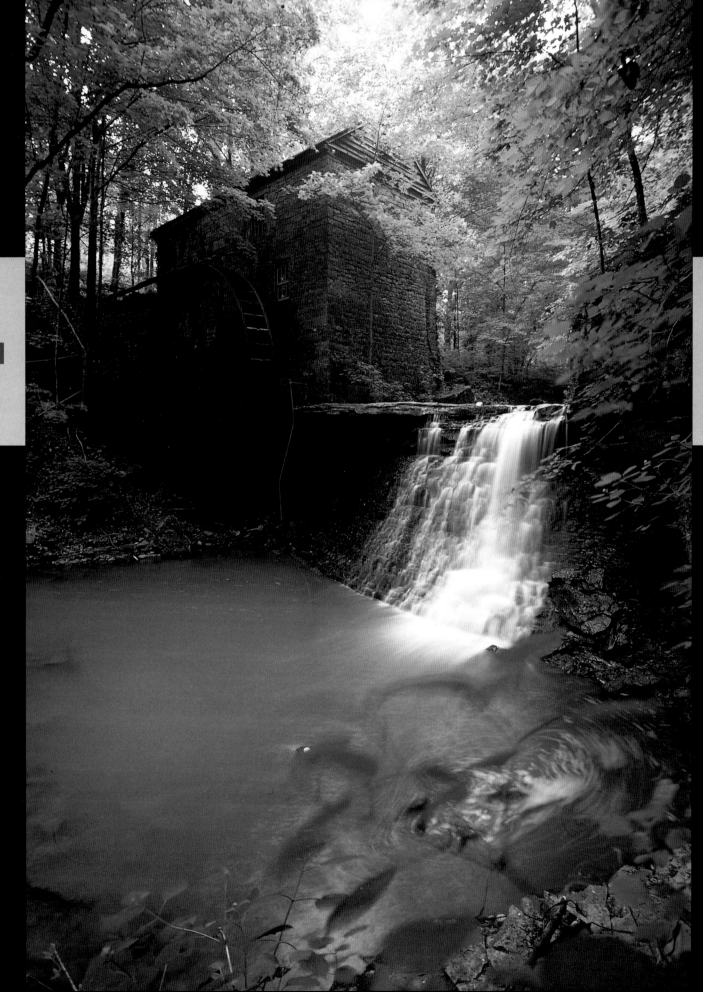

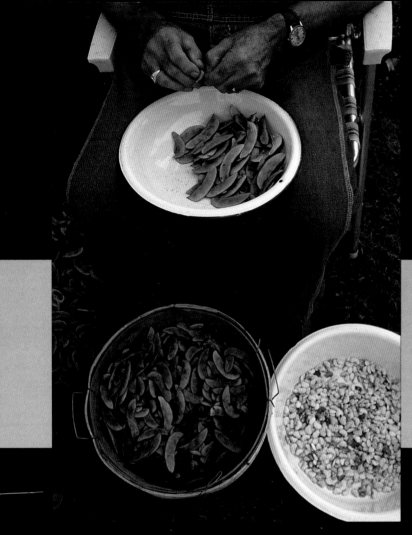

Left: *A lapful of snap beans.*
Below: *Ice cream party.*

Facing page: *Stone-ground meal makes the best cornbread. Wolf Pen Branch Mill near Crestwood.*

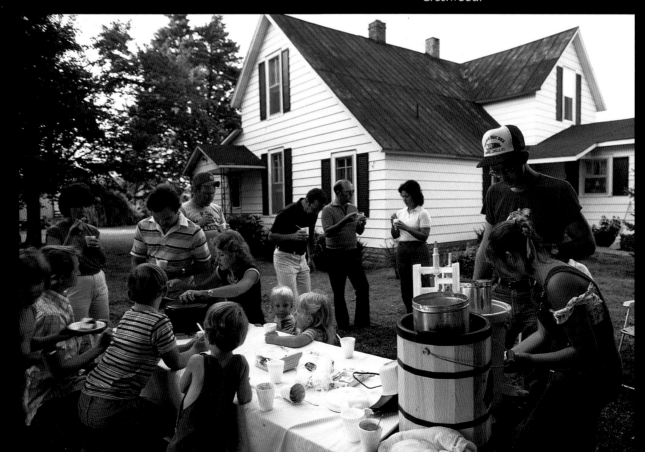

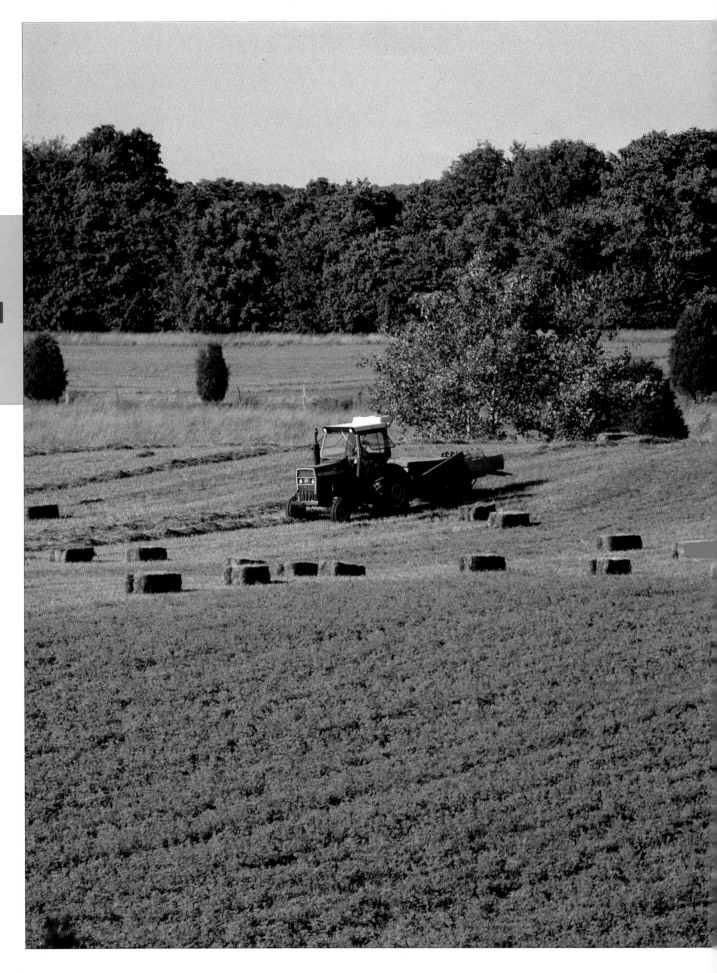

A house guest discreetly asked an elderly servant: "Tell me, how does one get to be a colonel in Kentucky?"

"Three ways, boss," was the reply. "You can go fight in the war and the general makes you a colonel. You can go see the governor in Frankfort and the governor makes you a colonel. Or you can give an old man like me a dollar—and I'll call you colonel all day long."

Hay baling in the central Kentucky.

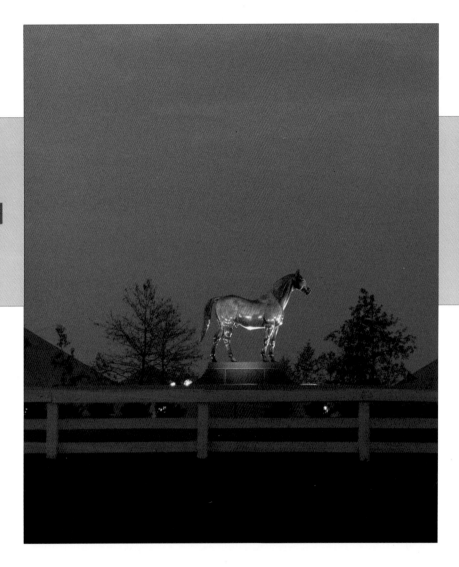

Above: Man o' War statue at Kentucky Horse Park near Lexington.
Right: State capitol dome at Frankfort, with the governor's mansion in the foreground.

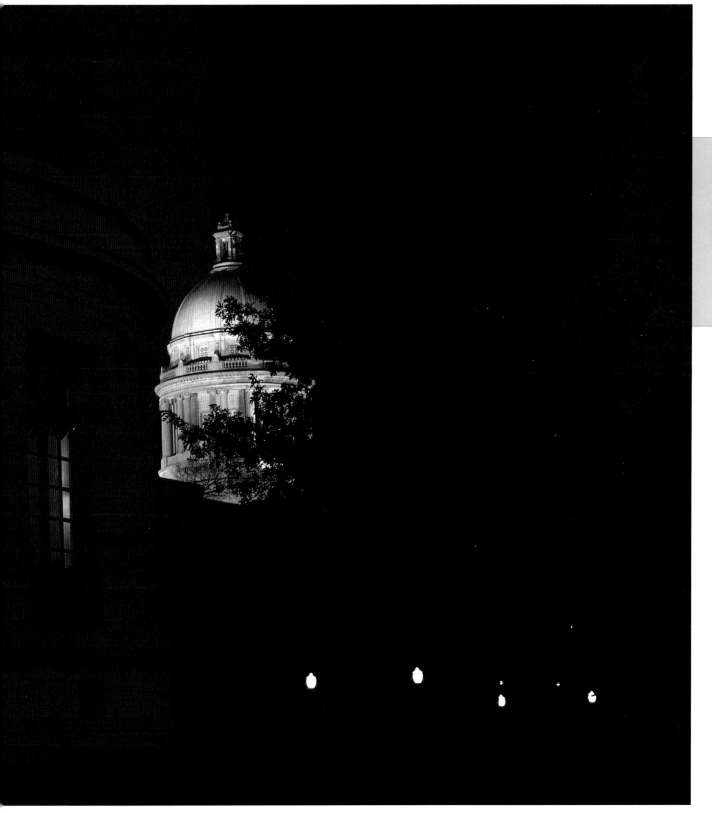

54

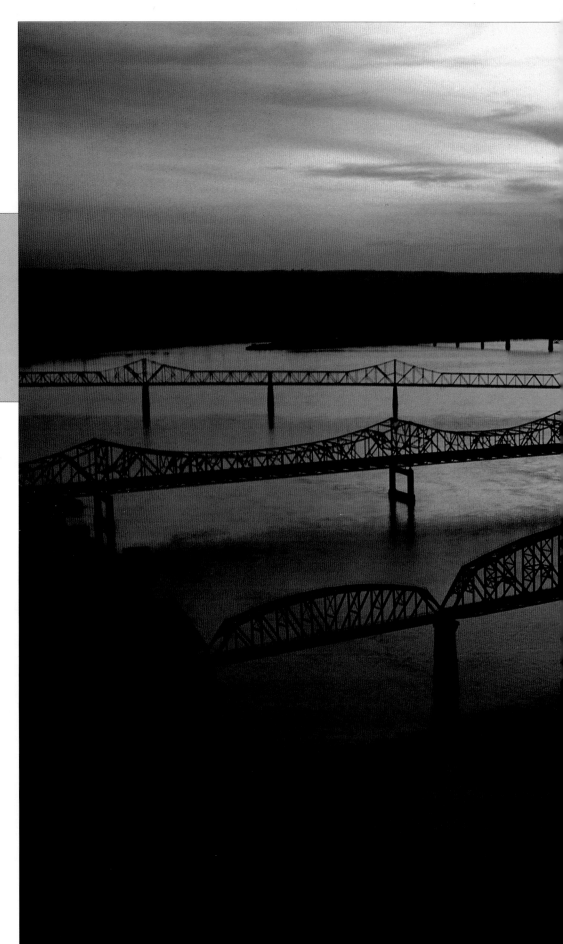

The bridges over the Ohio River at Louisville.

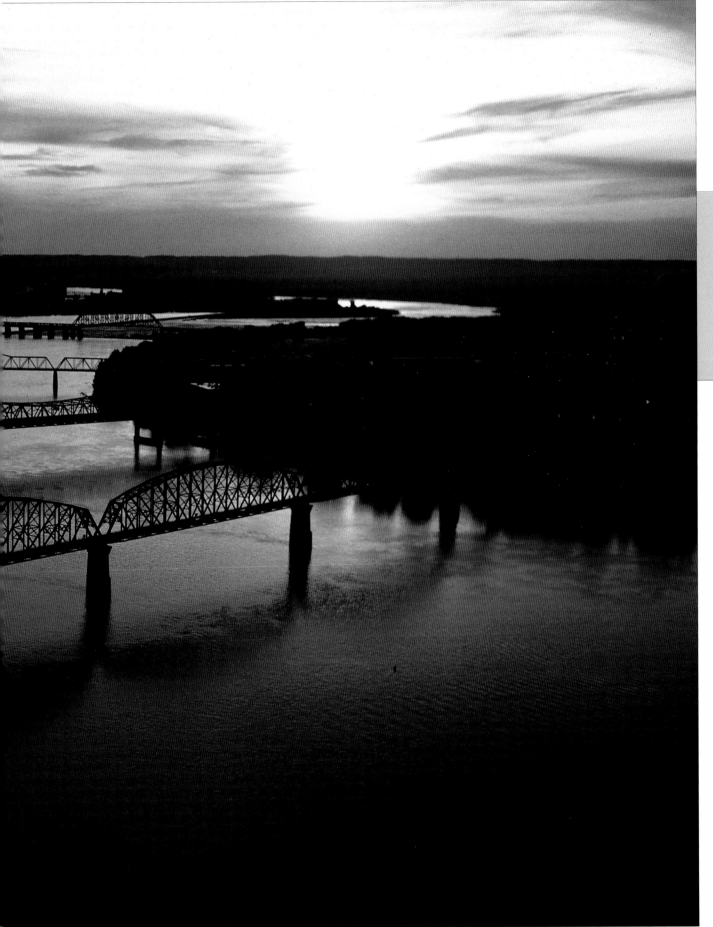

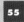

Toward the end of the 19th century, a sign outside Dixiana Farm in the Bluegrass Region read: "Nothing except a good racehorse wanted. Agents for the sale of books, patent machines, sewing machines, wheat fans, corn planters and ESPECIALLY lightning rods not admitted. Visitors who will come to my house are always welcome."

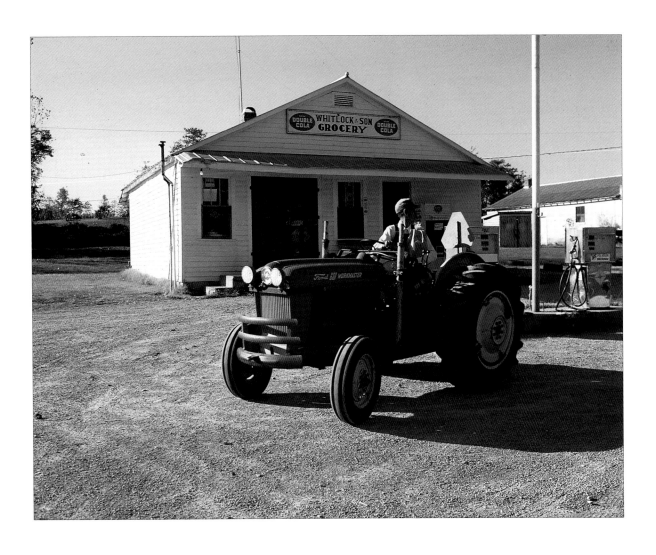

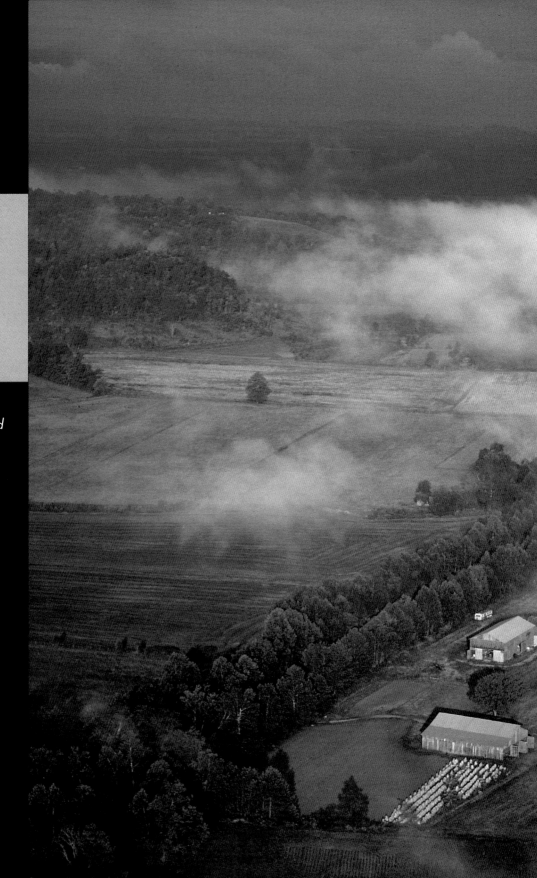

58

Central Kentucky farmland is old and beautiful.

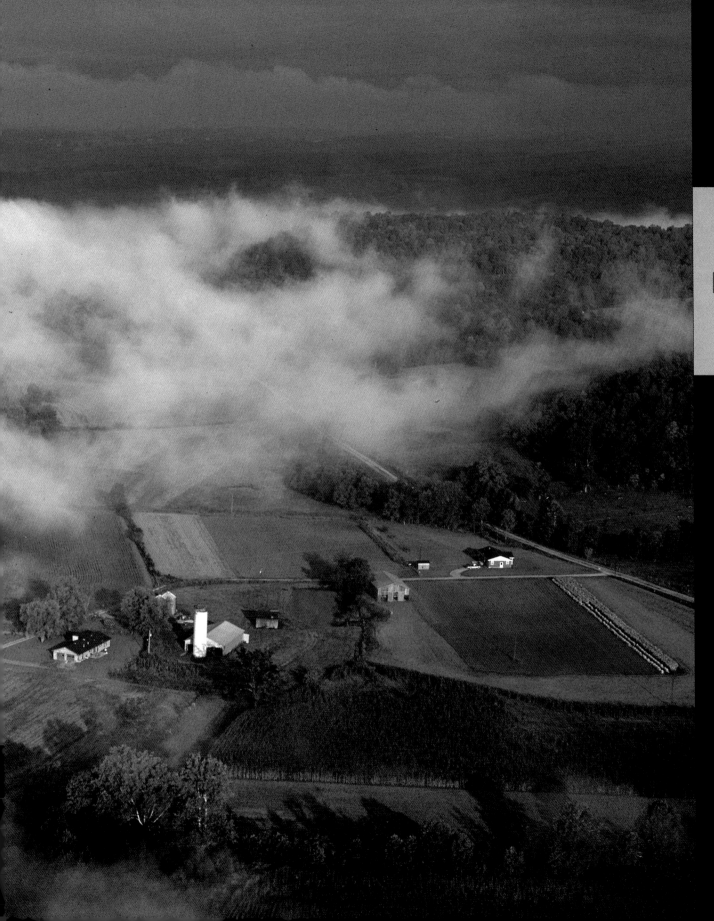

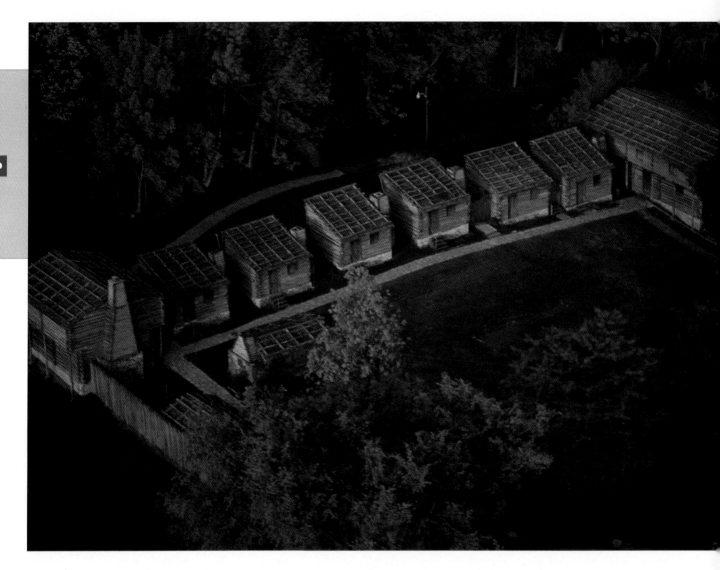

Above: Fort Harrod State Park.

Facing page: Perryville, a Civil War battlefield shrine.

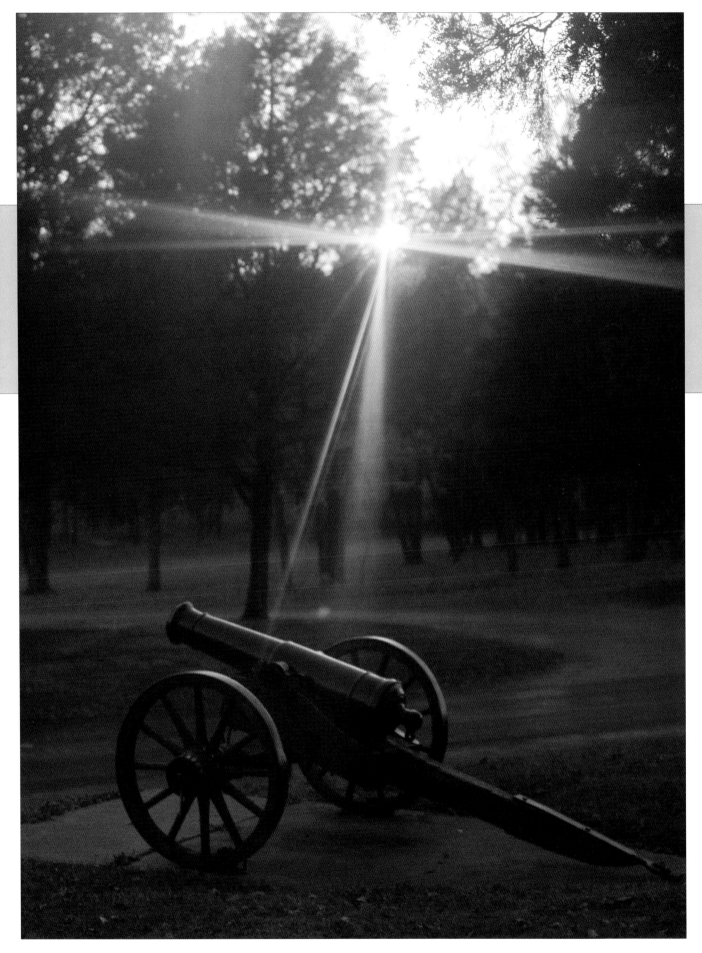

f all Kentucky foods, none is more debated than a thick, savory stew called burgoo.

There is a legend that Kentucky burgoo was first made with blackbirds during a Civil War meat shortage.

There are as many burgoo recipes as there are Kentuckians. Some include squirrel and turtle. Others simply suggest: "The last three things you hit with your pickup truck."

Below: Five strings and ten fingers at work.

Facing page: Bluegrass music is the pure sound of Kentucky.

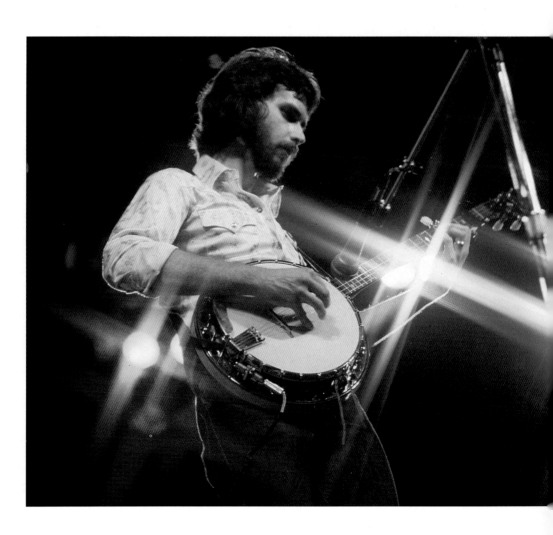

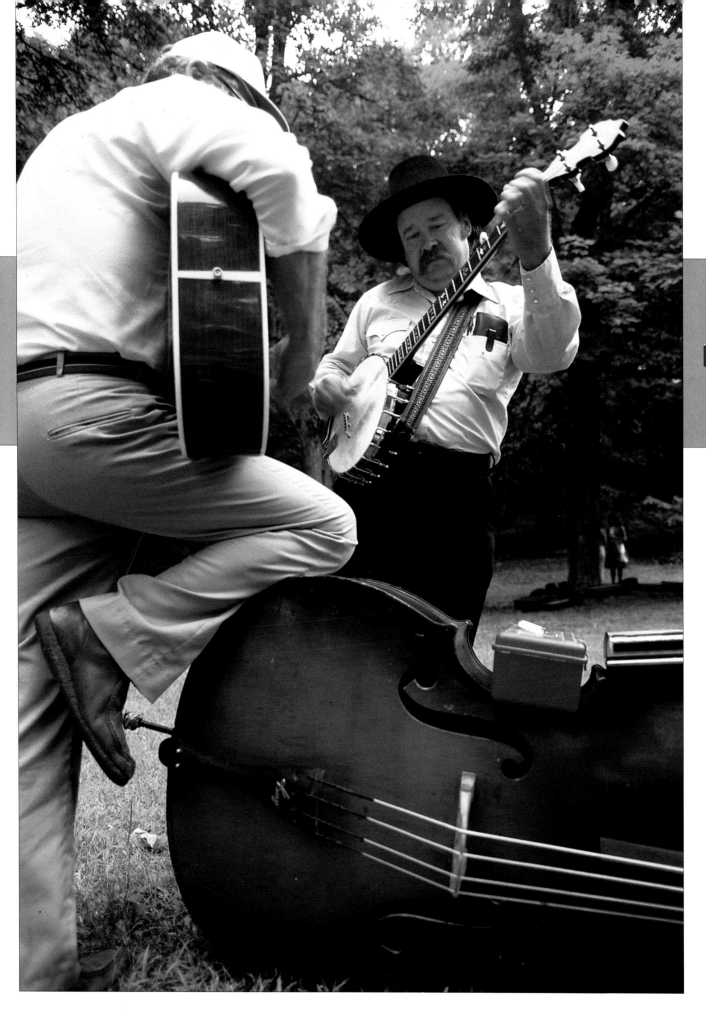

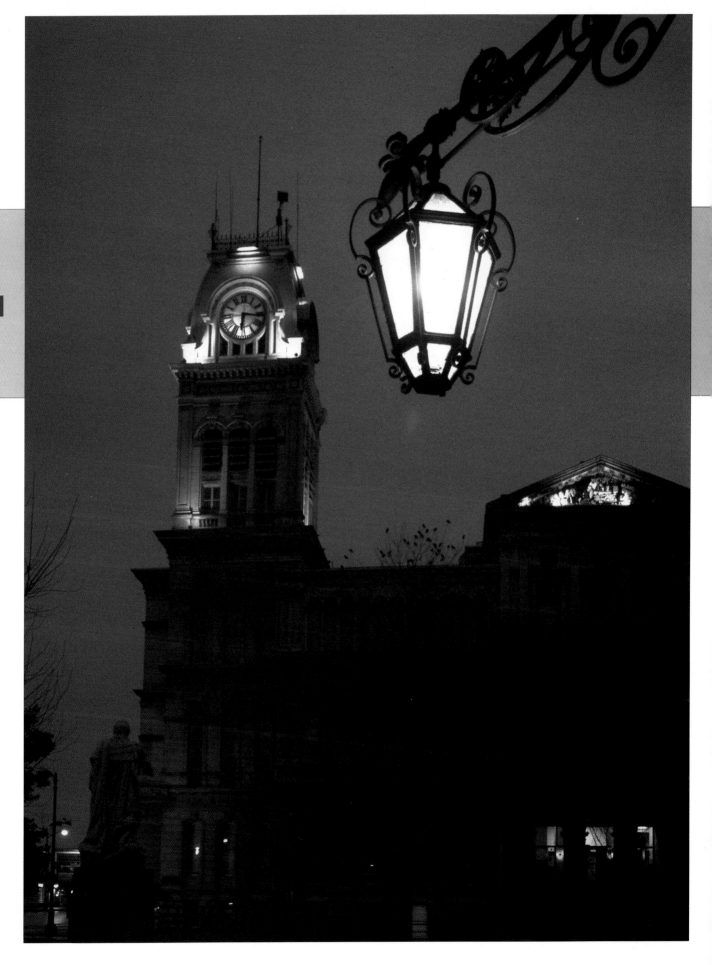

Above: *Church supper outside Hodgenville.*
Facing page: *The past is never far away on an old street.*
Louisville City Hall in background.

Nothing can keep a Kentucky hunter from the woods. The anecdote is told of two 'coon hunters and their hounds standing on a hillside at dusk, waiting for the moon to rise.

Far below a church bell rang.

"I reckon I'll miss prayer meeting tonight," said one.

"Me, too," said the other. "But I wouldn't have gone anyway, my wife being as sick as she is."

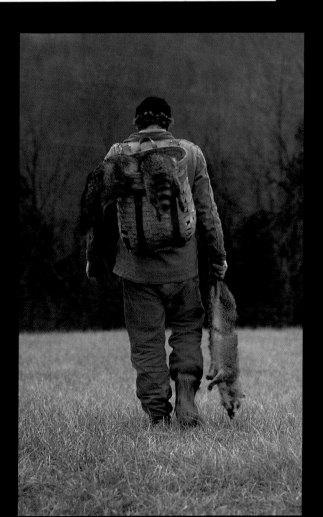

Above: *A foggy sunrise near Hodgenville.*
Left: *Some people still make their livings by trapping.*

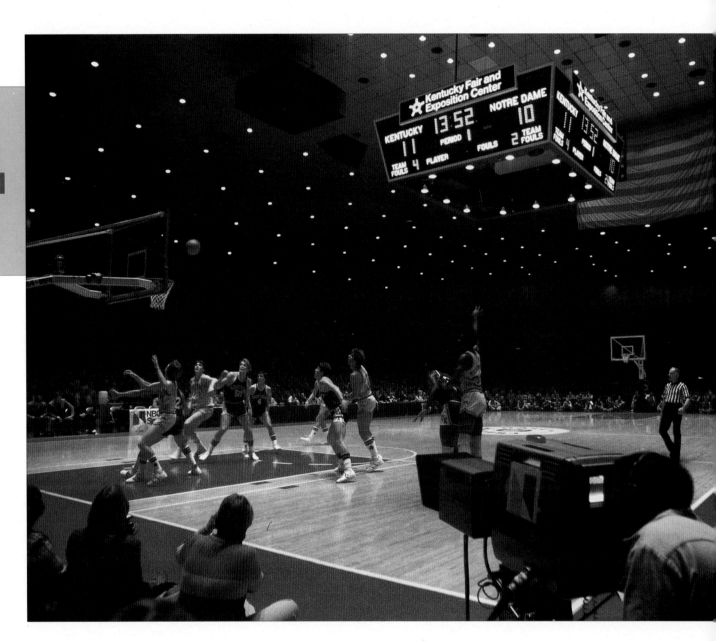

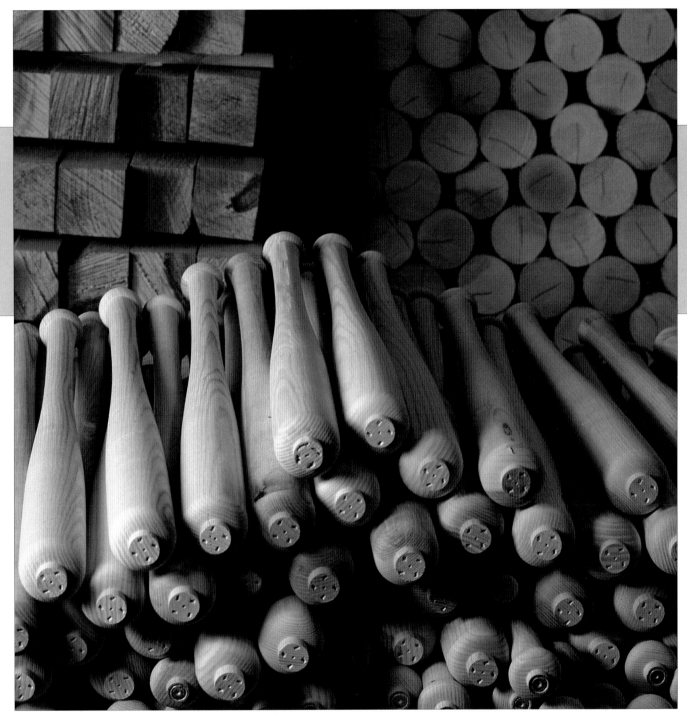

Above: Louisville Slugger baseball bats in the making.
Facing page: The most popular Kentucky sport is
basketball.

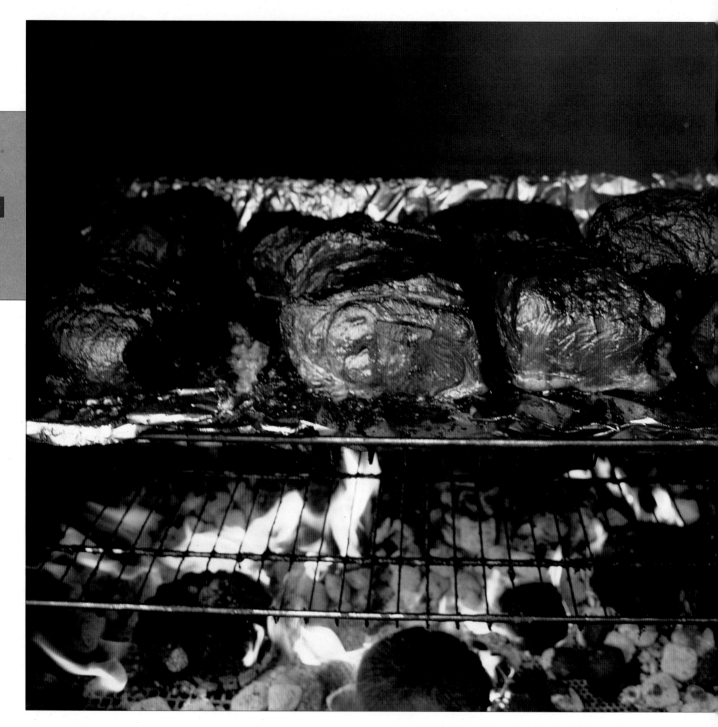

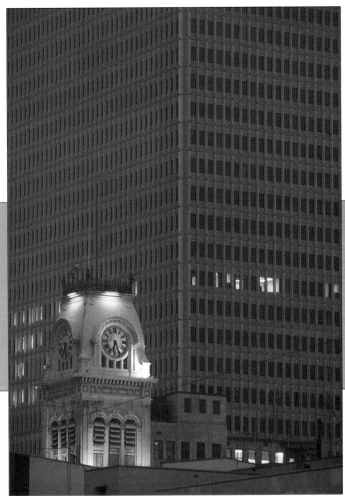

Left: *Louisville City Hall.*
Below: *Planning his next adventure.*

Facing page: *Barbecue is a high art form in Kentucky.*

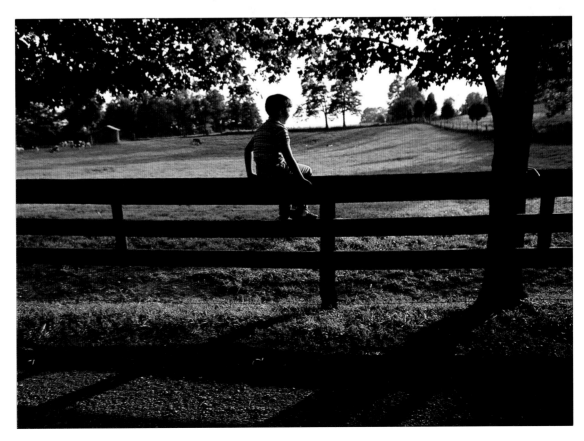

73

The Ohio River
separates Kentucky
from the Midwest.

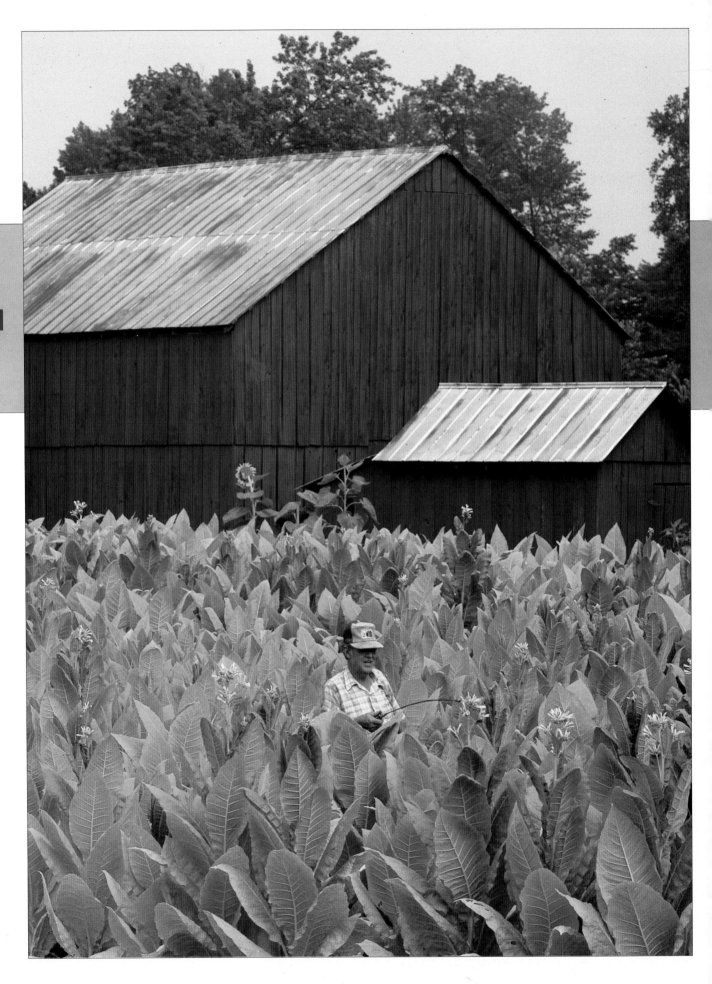

Those left who speak the old Kentucky language are never merely happy; they are "as happy as a 'possum in a persimmon tree with a dog a mile away." To them, a night is "black as a wolf's mouth," a hot day is "hell biled down to a pint" and a person of foolish judgment is "half a bubble off plumb," just as a carpenter's level would be.

Other Kentuckians are not as voluble. But even these, if you ask them a question, they won't merely answer it. They will tell you a story.

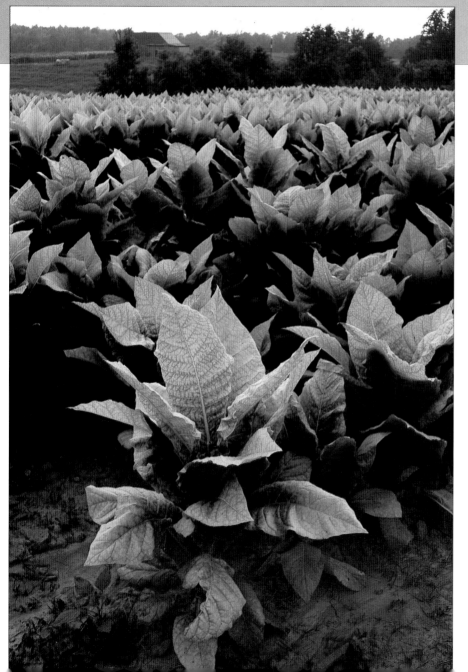

Left: *Burley is the choicest leaf.*

Facing page: *Tobacco season.*

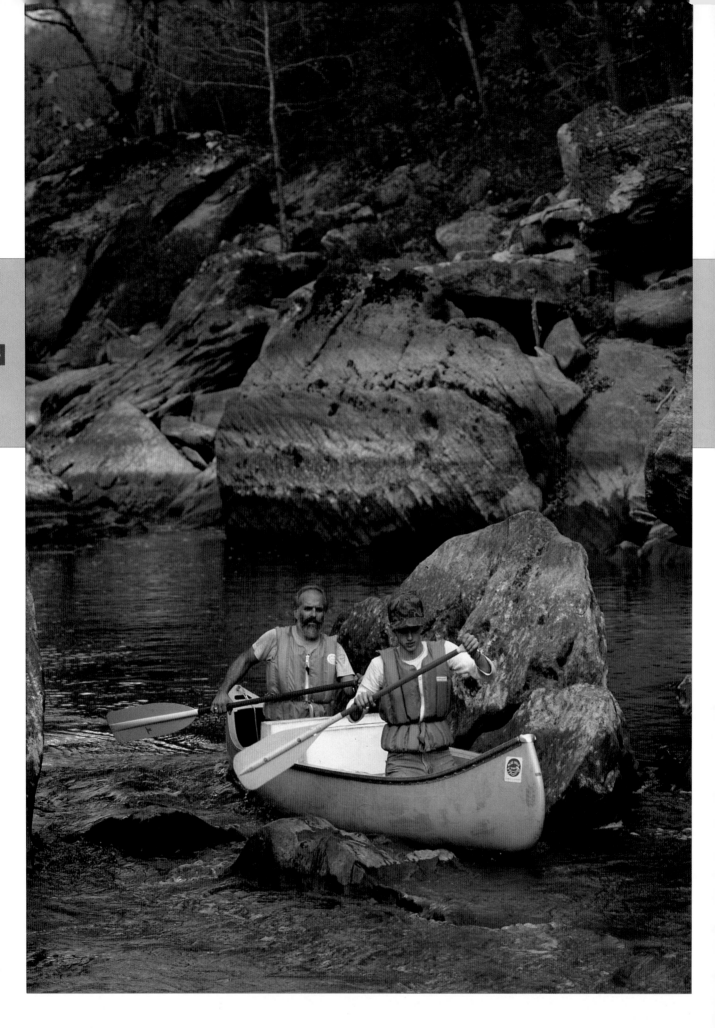

Left: Log splitter in the mountain timber country.
Below: Sky Bridge in the Red River Gorge area, Daniel Boone Forest.

Facing page: Canoeing Rockcastle River.

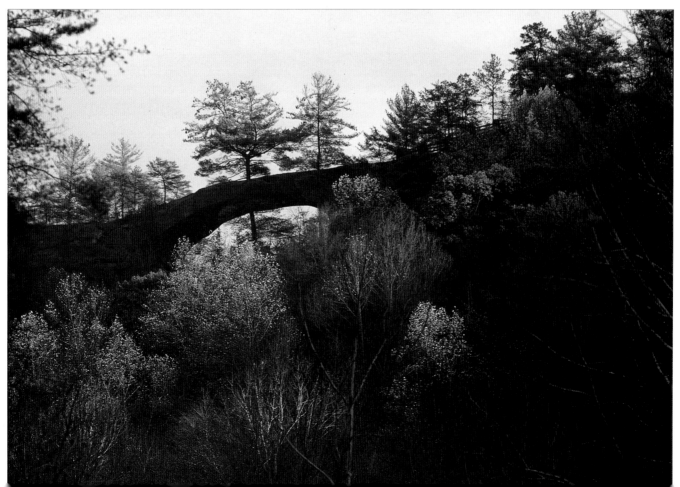

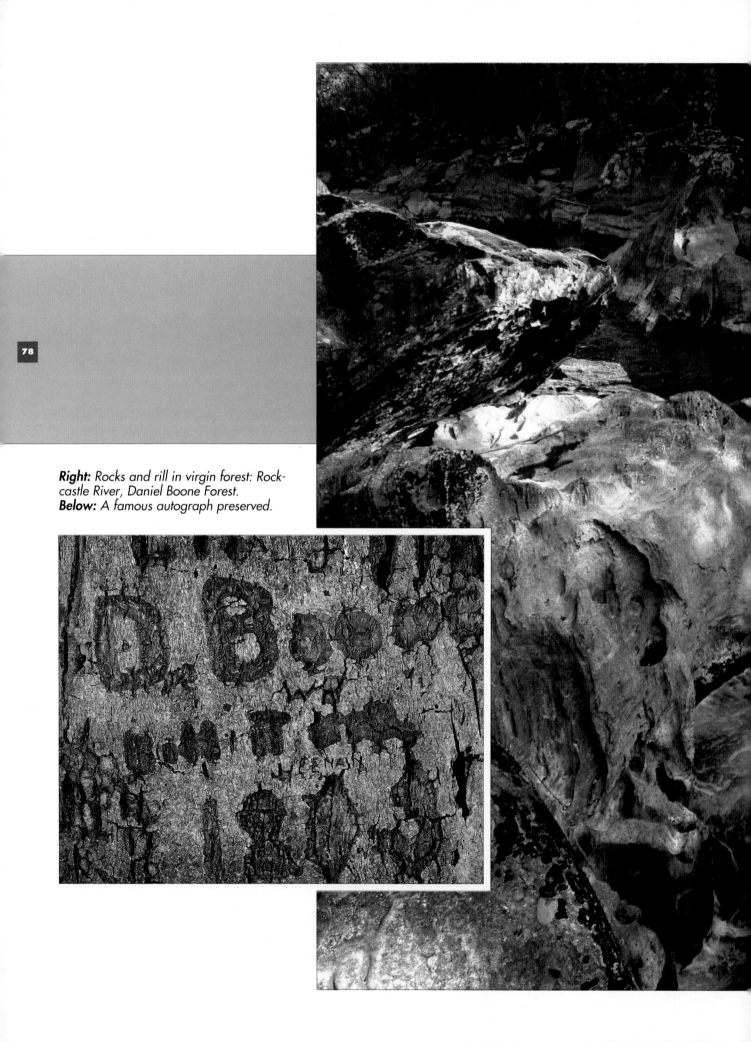

Right: *Rocks and rill in virgin forest: Rock-castle River, Daniel Boone Forest.*
Below: *A famous autograph preserved.*

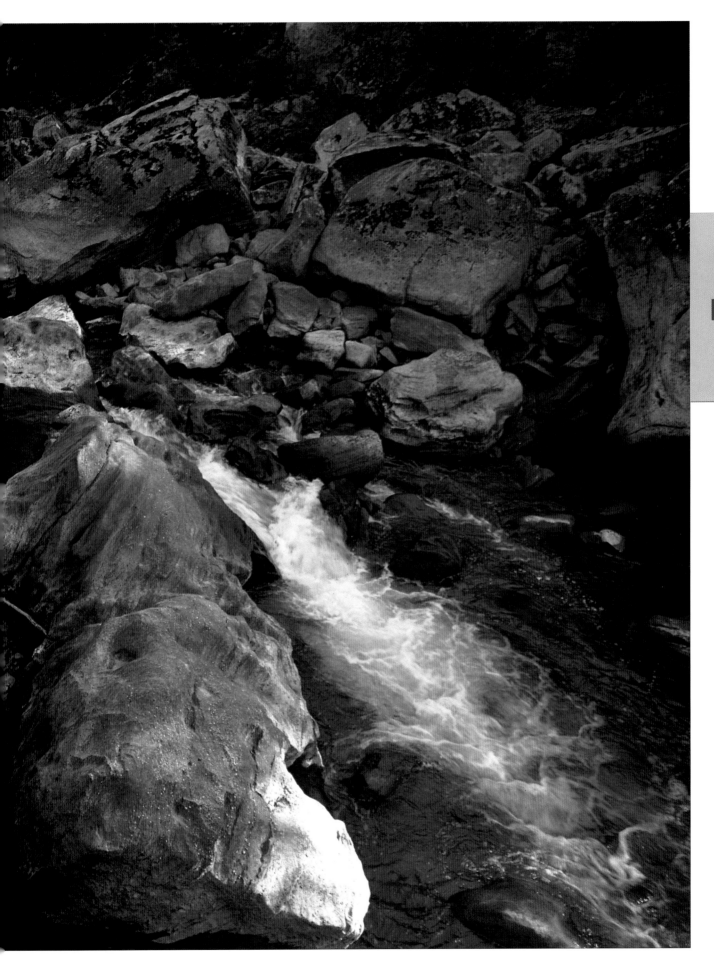

Below: Every quilt design has a special meaning.

Facing page: Kentucky weaving—here at Churchill Weavers, Beria—is shipped the world over.

Kentucky has a lost silver mine, a prehistoric underground city, sunken steamboats, covered bridges and so many horse cemeteries and old mansions with secret rooms that nobody has bothered to keep count of them.

Not everything worked out here. But even the things that didn't are of interest.

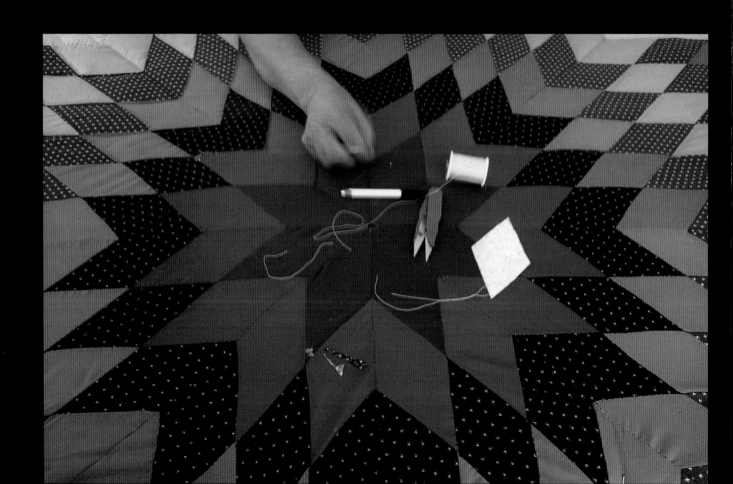

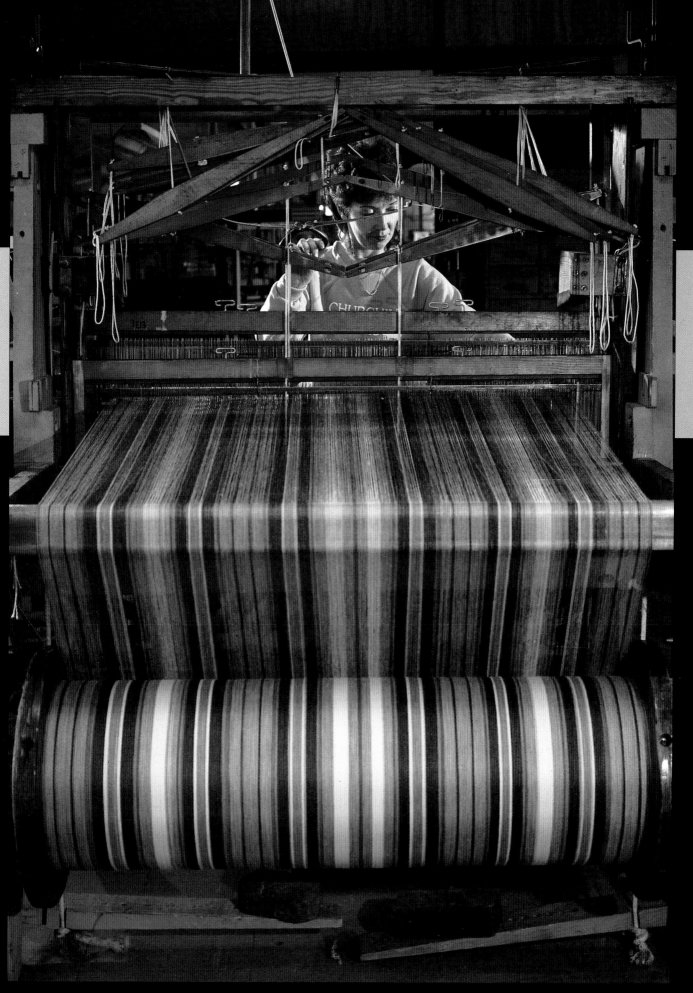

Above: *Welcome, stranger.*
Right: *Harvest and sunset.*

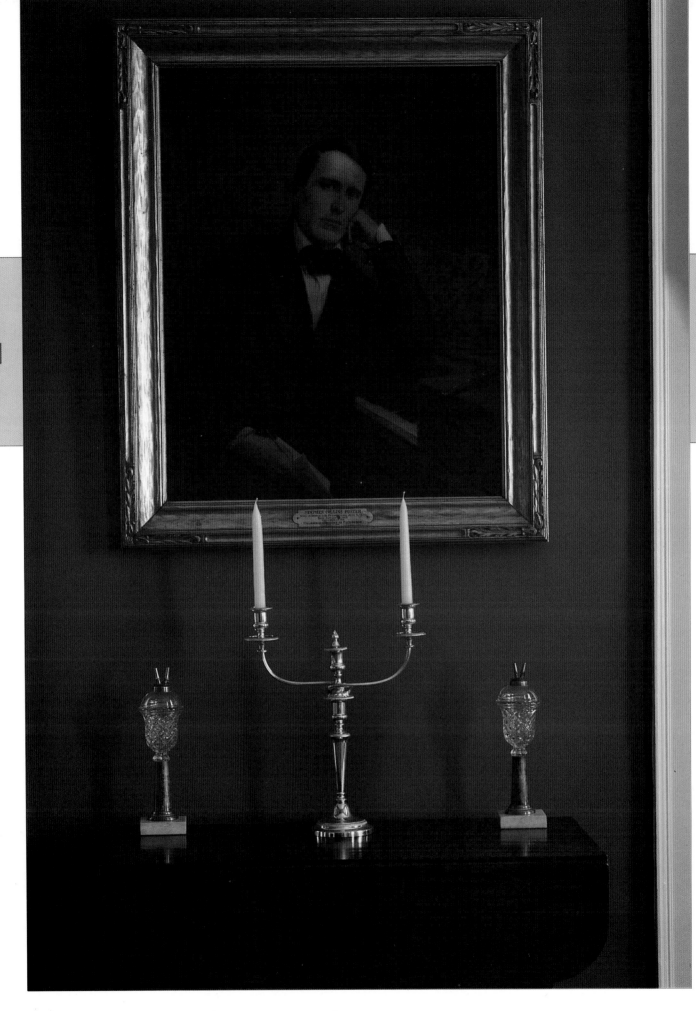

On the Cumberland River, between cliffs lined with hemlock and sweetgum, is a falls that drops 68 feet and at night creates a moonbow in its mist, one of only a few regularly appearing moonbows on the continent.

A utility company wanted to dam the river to build a power plant. A Kentuckian bought Cumberland Falls and its virgin forest and gave it to the state.

No better investment was ever made in the uncommon wealth of the commonwealth.

Below: *Patriotic home delivery.*

Facing page: *Stephen Foster portrait at "My Old Kentucky Home" state shrine, Bardstown.*

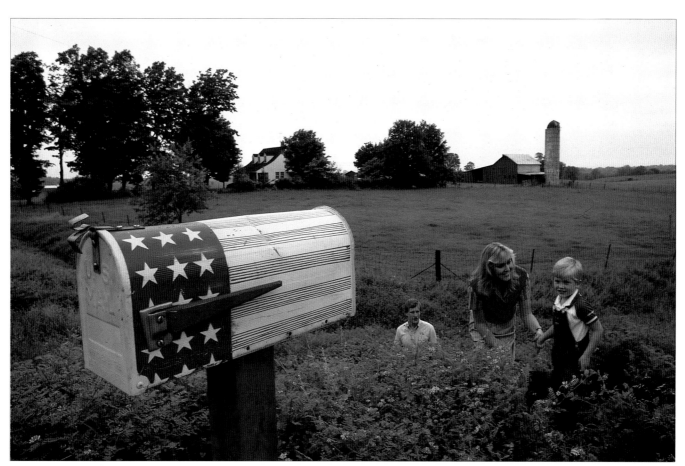

Right: Thoroughbred yearling auction at Keeneland Race Course, Lexington.
Below: Locust Grove, a Kentucky country estate.

Facing page: The earliest type of old Kentucky home, and Abraham Lincoln's boyhood home, Knob Creek.

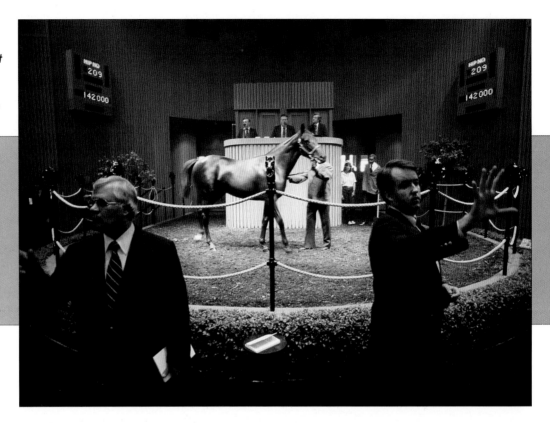

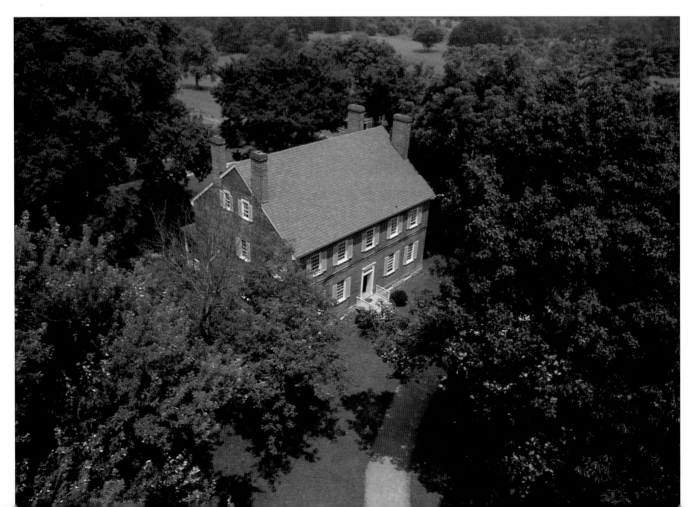

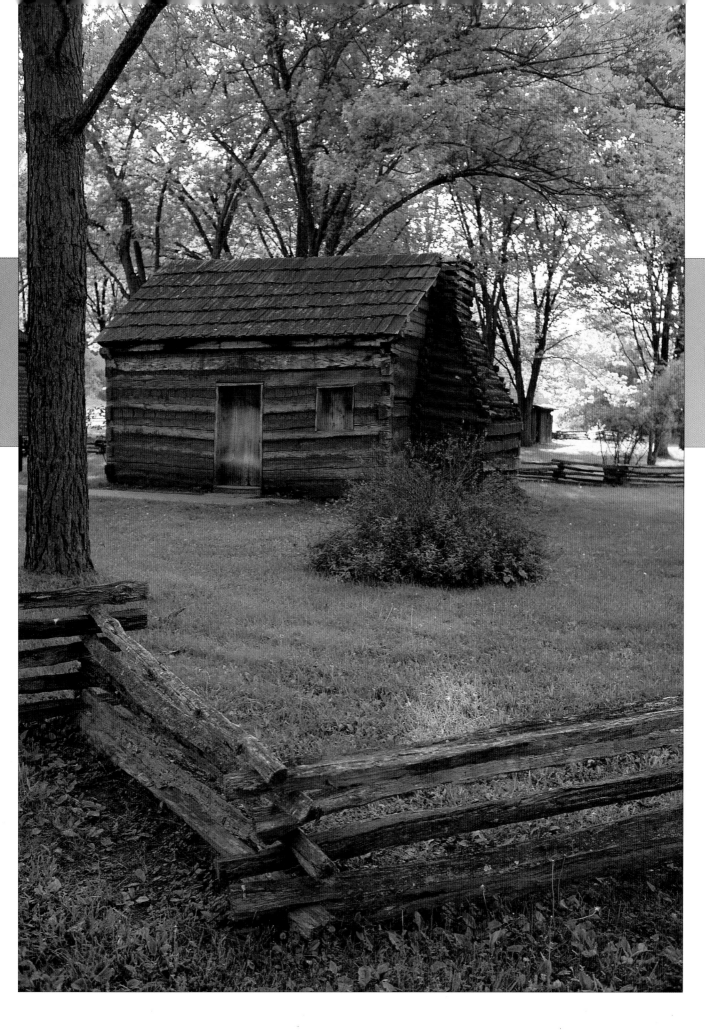

Right: Coal mine, "where it's dark as a dungeon and damp as the dew."
Below: Trees dressed up for autumn.

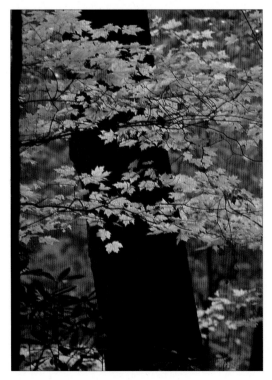

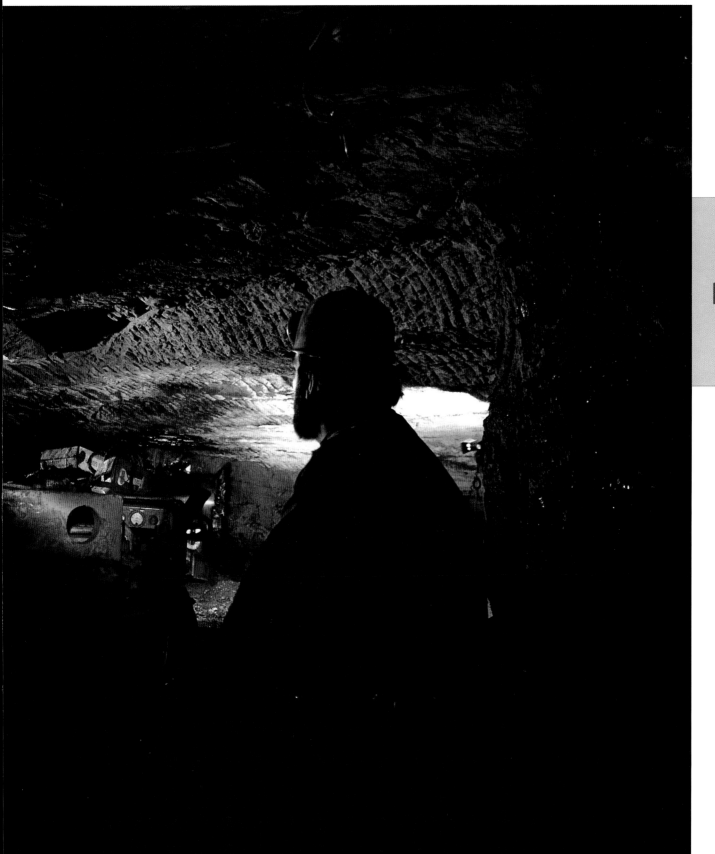

A Kentucky moon-shiner once offered this test of his product's potency:

Three people drink a quart of white lightning.

One of them leaves.

The other two try to guess which one left.

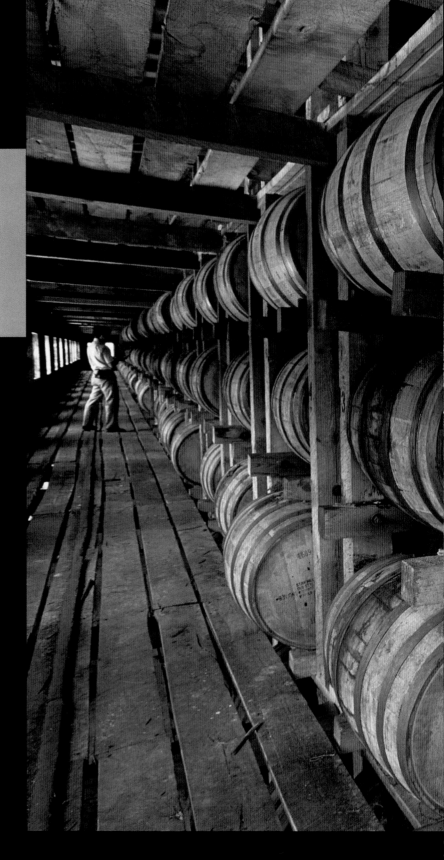

Bourbon barrels where the best whiskey ages for years.

Right: Hometown football is the biggest Friday night show in most small towns.

Below: Church-going is an integral part of traditional Kentucky life.

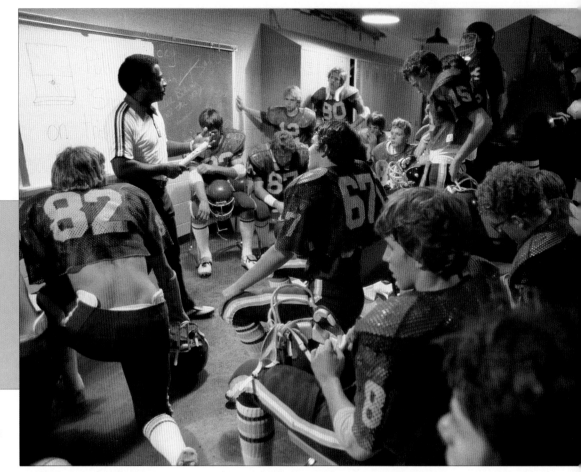

Facing page: No one forgets this was the 15th state admitted to the Union.

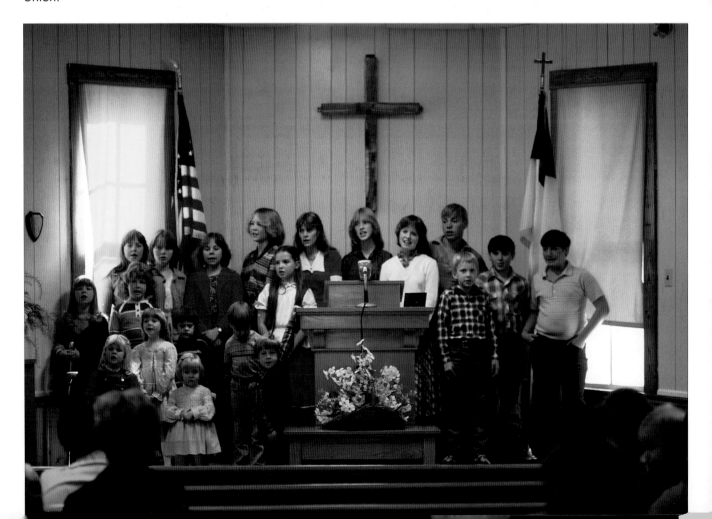

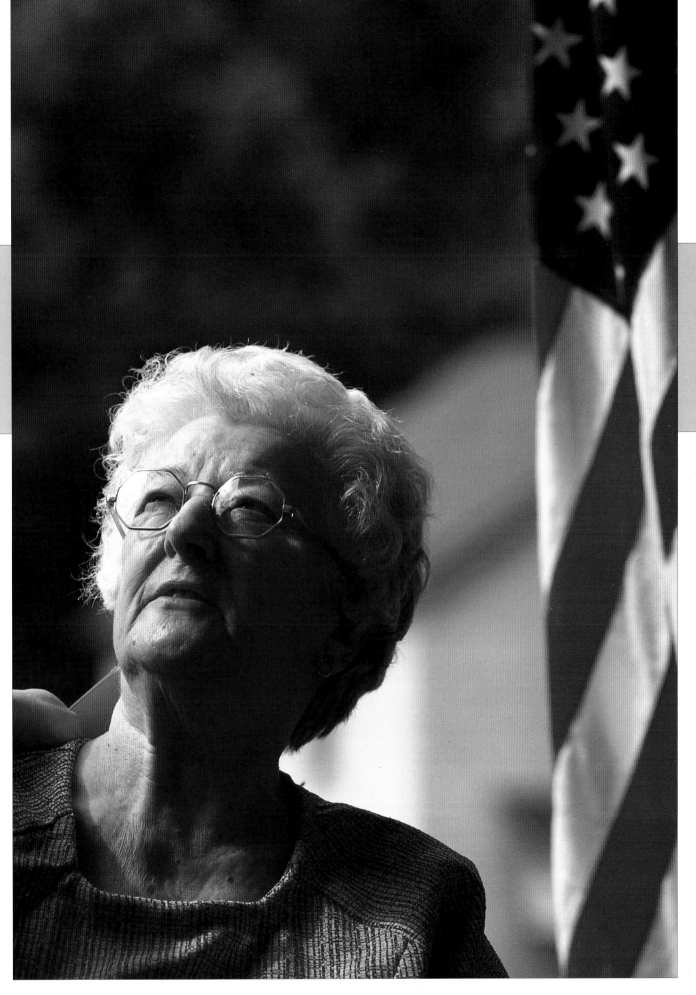

In the end, the limits of our experience are the limits of our world—and so there are many Kentuckys.

The best way to approach this place (and perhaps any place) is as an amateur.

By definition, an amateur does a thing for the love of it alone.

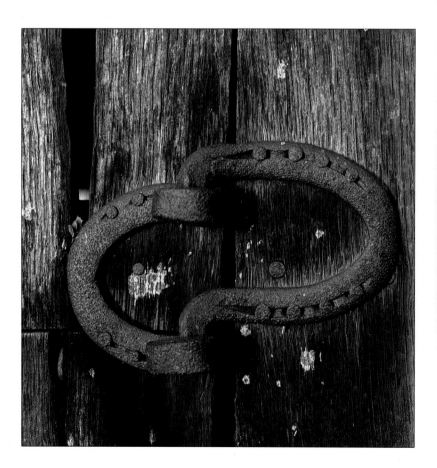

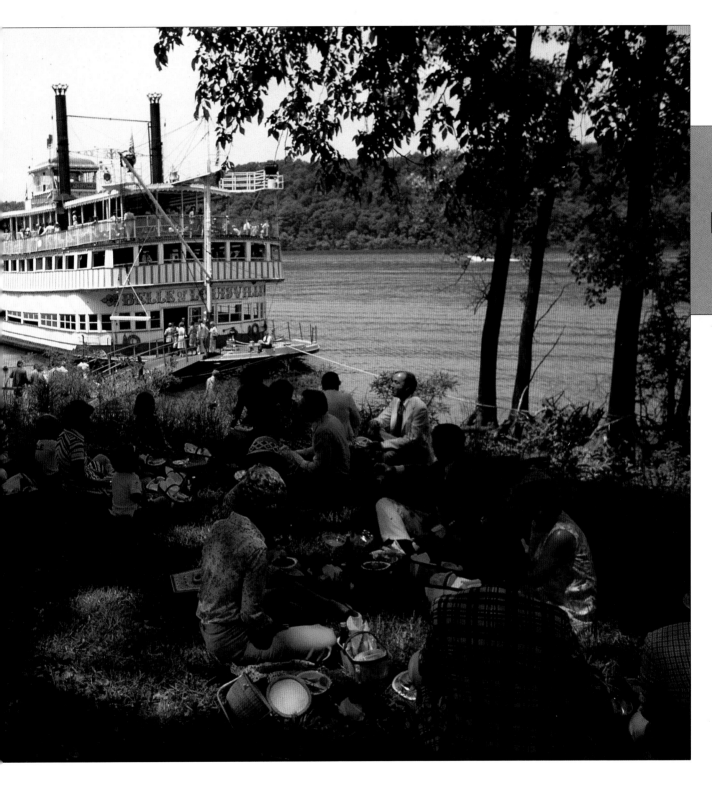

Above: Belle of Louisville *steamboat.*

Facing page: *A lucky barn door hinge made of horseshoes.*

Overleaf: *Woodcarver Tim Hall at work on duck decoy.*

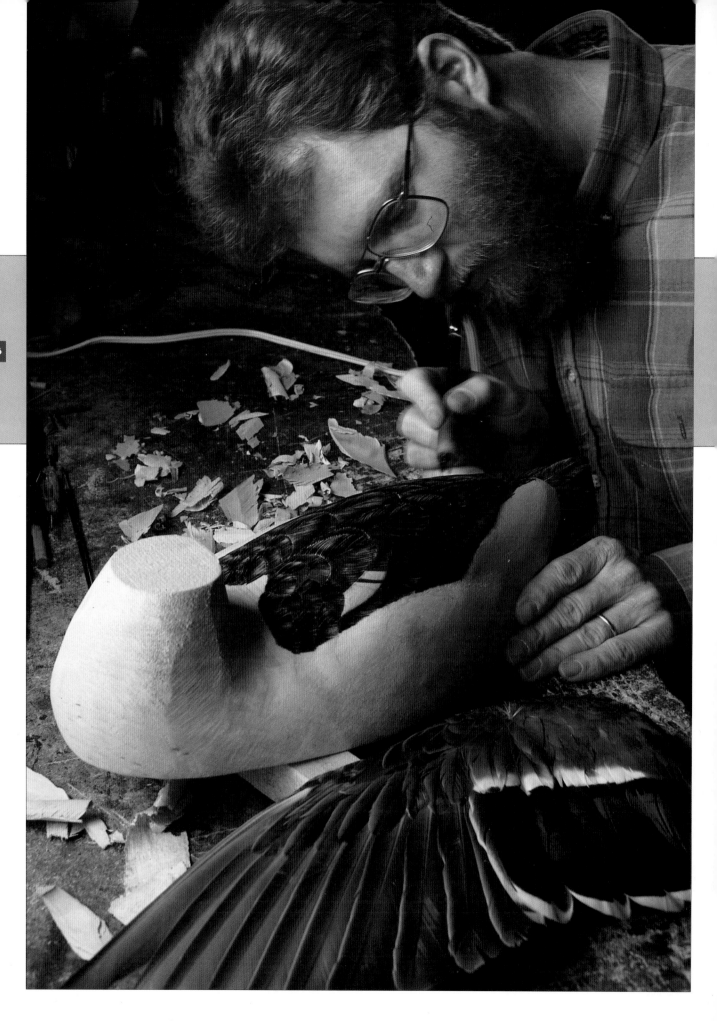